DAVID JONES 1895–1974: A MAP OF THE ARTIST'S MIND

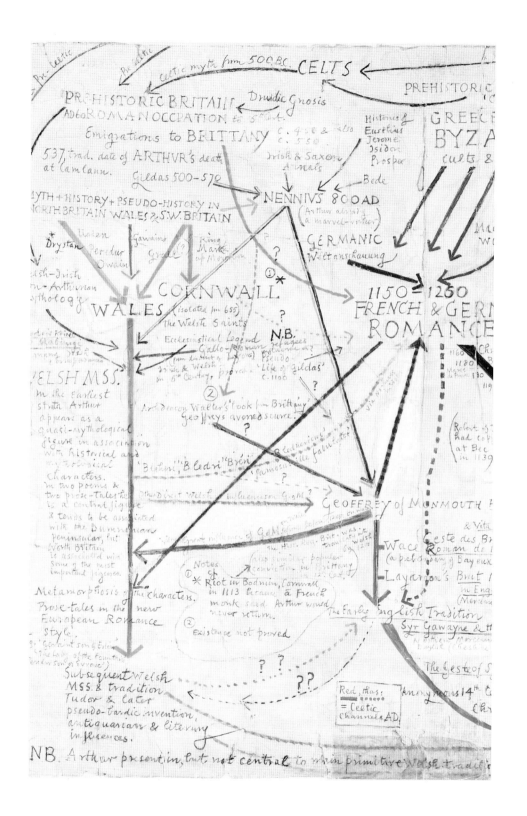

Celtic myth from 500 BC CELTS
Pre-Celtic Pre-historic Druidic Gnosis PREHISTORIC

PREHISTORIC BRITAIN Histories of GREECE
AD60 ROMAN OCCUPATION to 5th cent. Eusebius BYZA
Emigrations to BRITTANY c. 450 & also Jerome Cults &
c. 550 Isidore
537, trad. date of ARTHUR's death Irish & Saxon Prosper
at Camlann. Annals Bede
Gildas 500-570
MYTH + HISTORY + PSEUDO-HISTORY IN NENNIVS 800 AD
NORTH BRITAIN WALES & S.W. BRITAIN (Arthur already Ma
a marvel-maker) W
Drystan Peredur Gawain King GERMANIC
Owain Grail (?) Mark Weltanschauung
of Moriam
Welsh-Irish ① ✱ 1150 = 1260
non-Arthurian CORNWALL FRENCH & GERM
mythology WALES (isolated fm 655) ROMANCE
The Welsh Saints 1160
Ecclesiastical Legend N.B. 1180
Gallo-Roman refugees Marie
from diocese of Lyons Pseudo- 130
Irish & Welsh 'Life of Gildas' 119
WELSH MSS. in 6th Century, proved C. 1100
In the earliest Robert of
strata Arthur ② had cop
appears as a Archdeacon Walter's 'book' from Brittany at Bec
quasi-mythological Geoffrey's avenues obscure. in 1139
figure in association
with historical and ?
mythological
characters. "Bahur" "Bledri" "Bren" fabricator
in two poems &
two prose-tales he Other Direct Welsh influences on G.o.M. ?
is a central figure GEOFFREY of MONMOUTH
& tends to be associated
with the Dumnonian & Vit
peninsular, but Geste des Br
North Britain WACE Roman de
is associated with (a prebendary of Bayeux
some of the most Layamon's Brut
important figures. (in Eng
(Worcester
Metamorphosis of the characters. The Early English Tradition
Prose-tales in the new ① Notes Syr Gawayne & the
European Romance ✱ Riot in Bodmin, Cornwall (Northern Worcester
style. in 1113 because a French Carlisle (Cheshire
"Gerant son of Erbin" monk said Arthur would
"The Lady of the Fountain" never return. The Gest of S
(Owein son of Urien)
② Existence not proved anonymous 14th C
Subsequent Welsh
MSS. & tradition Ch
Tudor & later Red, thus:
pseudo-bardic invention, = Celtic
antiquarian & literary ? ? ? ? Channels AD.
influences.

NB. Arthur present in, but not central to main primitive Welsh tradition.

DAVID JONES 1895–1974

A MAP OF THE ARTIST'S MIND

Merlin James

with contributions by Arthur Giardelli, Nest Cleverdon and Kathleen Raine

Lund Humphries Publishers, London in association with National Museums & Galleries of Wales

FRONTISPIECE
Map of Themes in the Artist's Mind (detail) 1943
Pencil, ink, watercolour and body colour
51.2 x 61.3 cm
Fig.30 (Cat.7)

FRONT COVER
Portrait of a Maker 1932
Oil on canvas
76.2 x 61 cm
Colour Plate 3 (Cat.14)

First published in Great Britain in 1995 by
Lund Humphries Publishers Ltd
Park House
1 Russell Gardens
London NW11 9NN
in association with National Museums & Galleries of Wales

David Jones 1895–1974: A Map of the Artist's Mind
© 1995 National Museums & Galleries of Wales
Texts © 1995 The Authors
Reproduction of works by David Jones © 1995 Trustees of the David Jones Estate

British Library Cataloguing in Publication Data
A catalogue record for this book is available from the British Library

ISBN 0 85331 679 1

Made and printed in Great Britain by BAS Printers Limited,
Over Wallop, Hampshire
Designed by Ray Carpenter

Published to accompany the exhibition:
A Map of the Artist's Mind: David Jones 1895–1974
A Centenary Exhibition

Glynn Vivian Art Gallery, Swansea 30 September–12 November 1995
Hove Museum and Art Gallery, Hove 19 November 1995–28 January 1996
National Museum & Gallery, Cardiff 17 February–14 April 1996

AMGUEDDFEYDD AC ORIELAU CENEDLAETHOL CYMRU
NATIONAL MUSEUMS & GALLERIES OF WALES

Contents

Acknowledgements

A list of lenders to the exhibition is published at the end of the catalogue section of this publication. The authors and exhibition organisers wish particularly to thank the following for a whole variety of contributions and efforts around this publication and the accompanying exhibition:

Derek Shiel, Nest Cleverdon, Huw Ceiriog Jones, John Austin, Alison Lloyd, Tim Wilcox, Edmund Gray, Sophy Gray, the Trustees of the David Jones Estate, Edgar Holloway, Paul Hills, G. Ingli James, Stanley Honeyman.

We are also grateful to colleagues in curatorial, conservation and technical support at the National Museums & Galleries of Wales and particularly to Sylvia Richards and Lynette Edwards in dealing with the administration of the exhibition and the publication's text and to colleagues at Lund Humphries.

David Alston
Merlin James
August 1995

Preface

WHAT WOULD David Jones have made of our marking his centenary? Perhaps he would have reflected on the rather arbitrary time span of the personal one hundred years, set against the sense of continuum his historical imagination could court.

He would perhaps have mused on the nature of the artist's activity – of forming, shaping but ultimately letting go of something which is then submitted to the forming and shaping of other people's perceptions and understandings. In the intervening period since his death, artistic and literary trends – since he straddles both – have begged a re-appraisal of his situation as an artist. He seems now less of a stranded humanist beached on the twentieth century's modernist shore, than somebody looking already beyond the vacuity of much post-modernism and its inability to satisfy our curiosity about the artistic impulse. For Jones the great artistic event of his centenary year would probably not have been the wrapping of the Reichstag, but the discovery of the repeated, ritualised re-drawing by early people of animal imagery in dark caves deep inside the mountains at the Grotte Chauvet in south-eastern France.

There would be some satisfaction for David Jones, no doubt, in seeing this centenary marked in Wales – but that this chance of re-appraisal would also place him in a broader European context than hitherto might also be welcome. David Jones was not an insular creator. Because his historical imagination understood the operation of culture over wide exchanges and terrains, so he was prescient of the evolving situation for the modern artist – as expressed in his 1944 essay *Wales and Visual Form*. As new people come to his work on this occasion – something we hope this publication and the exhibition achieve – they are discovering an artist with an intense sense of contemporary potentialities. He concluded his 1944 essay, 'All that has been attempted is to suggest the kind of background against which, and the kind of situation within which, any local expression or expression deriving ultimately from these old localities, must now operate – in or from or obliquely of, Wales, England, or elsewhere. There is every reason to suppose that much such expression will, one way and another, continue under these very changed and rapidly more changing, world conditions. The machine age may see an intensive productivity in certain specified arts – even for instance painting: that quite well fits this picture; but it will be painting as a separate "cultural" (in the new sense) activity. Already we see a great "interest" displayed in these different cultural activities. The next hundred years or so may be very interesting a propos of this business of technological man and man the artist. It is impossible to say how the spirit of man will resolve the antitheses – including the spirit of man as expressed in Welshman.'

It seemed crucial to me when planning this centenary exhibition to make a bridge from those familiar with David Jones's work to those of a new generation. This led to commissioning new writing from the artist and critic Merlin James who could be

guaranteed to build his arguments on a disciplined scrutiny of the works. Offsetting his writing we approached three people of and around David Jones's circle, and are most grateful to Arthur Giardelli, Nest Cleverdon and Kathleen Raine for the insights they provide. This book is completed by a catalogue of the works displayed in the exhibition it accompanies. For the first time in an exhibition of paintings by David Jones we have attempted to create a feeling for the complex play of ideas and themes in his work – some will say by being somewhat simplistic about them – to show the links between reading, childhood, developing religious outlook, and understanding art, history, myth and being a human being. The National Museums & Galleries of Wales owe a profound debt of gratitude to institutions and particularly individuals who have consented to make treasured works available to this exhibition and its tour. Each visitor to the exhibition will have cause to appreciate such generosity in making the exhibition possible.

The 'Map of Themes' for the exhibition was supplied by Jones himself in an autobiographical note of 1935:

> I should like to speak of a quality which I rather associate with the folk tales of Welsh or Celtic derivation, a quality congenial and significant to me which in some oblique way has some connection with what I want to do in painting. I find it impossible to define, but it has to do with a certain affection for the intimate creatureliness of things – a care for, and appreciation of the particular genius of places, men, trees, animals, and yet withal a pervading sense of metamorphosis and mutability. That trees are men walking. That words 'bind and loose material things'.

David Alston
Keeper of Art, National Museums & Galleries of Wales

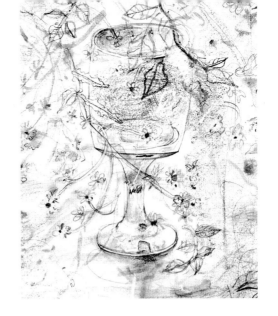

PORTRAIT OF A MAKER

MERLIN JAMES

DAVID JONES described his painting *Human Being* of 1931 (Colour Plate 2) as a 'quasi self-portrait',[1] and simply by looking closely at the work a viewer would come to the conclusion that it was exactly that. The shallow sill along the base of the composition suggests the bottom edge of a mirror in which the image of the figure is being seen. On the lower extremity of the painting, left of centre, there is an object which, while hard to identify (a dark ellipse with a fibrous or vaporous emanation – perhaps a smoking pipe), seems to be 'doubled' as if indeed reflected in a mirror behind it. Yet, the figure portrayed above does not quite have the presence of an artist directly confronting his self-image. The hands, for one thing, are not depicted in the act of depicting, and while one eye does appear to return the viewer's (or its own) gaze, the other is averted upward and sideways. The effect is somewhat that of a conventional portrait attitude, adopted with a hint of self-consciousness perhaps, but redolent of reposed, distant speculation. This is someone not reflecting upon self entirely, but partially lost to self, in thought.

Other factors also qualify our impulse to read the figure as a portrait of the artist. He appears rather too boyish and youthful to be the author of this picture, which despite (or because of) the ways it draws upon 'naïve' stylisations, is clearly a sophisticated work. The picture reads as a representation of adolescence (and if we know David Jones's date of birth, 1895, we will know that he was in his mid-thirties when he painted it). The boy in his out-sized clothes seems a still somewhat unformed identity, just as in the painting we are seeing his features loosely materialise and find their place out of a background flux. But also, finally, the depiction of the youth gives a strong suggestion of universality. Though there are certain specific characteristics, like the low, brushed-forward fringe and the wide, soft tie and collar (all of which we may recognise as faithful to Jones's own appearance), yet there are also schematic, non-naturalistic elements in the way the face and figure are delineated, indicating that this is not a portrait at all in the strict sense. The title, of course, confirms this. This human being, suspended between maturity and childhood, is also suspended between individuality and archetype. Within an informal field of marks and patches, the points of greater clarity are those representing the eyes, ear, nose, mouth and hands: the five senses of the human animal. That upwardly cast eye further creates an expression which traditionally implies, in a portrait, a sixth sense – a mental, imaginative dimension, and even the visionary or spiritual one of inspiration. (One thinks, for example, of the famous portrait by Thomas Phillips of William Blake.) The slightly skewed cast of the eyes in Jones's picture might even remind us of the traditional notion that the mongoloid squint of the 'village idiot' figure, sometimes included in early Flemish and Italian religious paintings, indicated one who had seen God directly.

The picture's emphatic delineation of the hands is also a drawing of attention to universal human faculties. Though they are not shown at work, yet they rest, in all their subtle articulation, ready for deployment. The human being is a maker, an artificer. The decorative hooks or handles beyond the sitter's left shoulder, the curtain with its floral pattern to the figure's right, the object hanging from one hook (possibly a kitchen implement but seemingly fashioned in the form of a fish), all hint at the kinds of handicraft of which he is capable, the culture which is natural to him. It is significant that these are objects at once functional and ornamental, for as this figure is both a physical animal and a spiritual, mental consciousness (accrued from a human clay of earth colours; conjured out of smoky, diaphanous layerings), so his products are both utilitarian and aesthetic. Those folded, entwined hands have tied that tie, a garment vestigially functional, primarily decorative. The hands, indeed, even in repose, are almost gesturing. They are full of their own potential significance, their own eloquence, their ability to make signs. They have a hint of benediction, a hint of the rhetorical gestures that are deployed in conjunction with speech. Their balanced interlocking creates, as if instinctively, a sense of physical and spiritual coexistence.

If this work presents the human being as maker, and maker of objects which are also signs, its own very explicit and obdurate madeness – its rough, physical marks, its candidness of method – spells out the fact that it is itself the product of such a maker. Whether or not the figure depicted happens to 'be' David Jones, this is, in a profounder sense, a portrait of the artist. Should we doubt such a reading, confirmation comes from another remarkable work by Jones from the following year, to which he gave the title *Portrait of a Maker* (Colour Plate 3). Here, despite a strikingly pointed profile, there is again the sense of a generalised type rather than an individual likeness. The picture reads almost as an emblematic 'character head', a physiognomy denoting a certain kind of man, as in Blake's 'Visionary Head' drawings (eg *The Man Who Taught Blake Painting*, or *The Man Who Built the Pyramids*). We look for evidence of the figure's attributes in his physical make-up. Certainly, in *Portrait of a Maker*, the hands are again emphasised, in particular the thumbs, those digits whose articulation most distinguishes human hands from the paws of animals. Like the face, though, the hands are still delicate, suggestive of an intricate and subtle making, rather than hefty manual labour. The figure once again has an otherworldly aura. There is an ethereal *sfumato* in the picture, in which the sitter's body seems to sublimate, in the strictly chemical sense of the word – to turn from solid directly to gas. The bottle on the shelf nearby suggests some alchemical elixir, perhaps symbolising a spirit contained in physical form: *Portrait of a Maker* is also about being human. And once more the picture has a sense of its own material madeness, its literal surface reiterated by intense scratchings hovering just

above the figure's hands.

Human Being announces its own artificiality at yet another level, by invoking art-historical tradition. The composition, with its frontal ledge on which the hands rest, the shallow space enclosing the figure, the three-quarter turn of the profile, the sense of a window or aperture beyond the head, the peripheral details or 'attributes' associated with the sitter – all these recall typical portraits from Western European Renaissance art. Above all, the hands recall that most famous example, *La Giaconda*; but they are characteristic of numerous other portraits (and it is known that David Jones was directly inspired in this work by the hands of a portrait of Charles VII by the French Renaissance painter Fouquet).[2] There may also be more distant and subliminal references at work. The roughly abraded, ochre-ish ground, over which are incised precise graphic summations of fingers, eyebrows, mouth, may fleetingly evoke wall paintings from classical antiquity or early Italian Renaissance murals. There is even something of cave paintings here (as there is in Jones's animal drawings of the same period), enriching the work's connotations of archetypal human creativity.

Human Being is also recognisable, stylistically, as locating itself within a more immediate tradition, that of a European modernism. Out of the activated, overall surface of the portrait, certain forms, and not at all the most explicable in terms of what they depict, appear to detach themselves and engage in a pattern of relationships within the picture plane. There are, for example, four very roughly lozenge-shaped forms – those of the orange tie; the red patch (a pocket handkerchief?) near the figure's right lapel; the already-noted, vaporous or fibrous effluxion on the bottom edge of the picture; and the umber, fish-like object hanging from the hook to his left. These shapes visually rotate around the hands like skittles being juggled. Or again, there is the echo of the dark, negative shape between the hands with the dark serpentine hook near the shoulder (an echo which strengthens the association of hand with artefact). Such formal play is on one level an inheritance from – even a conscious reference to – Cézanne, and more will be said later in this essay about the artist's relation to Post-Impressionism, and in particular to Roger Fry's and Clive Bell's theory, derived overwhelmingly from their understanding of Cézanne, that it was in abstract 'Significant Form' that the supreme value of works of art was to be found. Jones was to develop his own very individual version of that theory, one which is embodied in *Human Being*, not only in its degree of abstraction but also in what he would have held to be its *necessary* representationalism, and in its themes of human spirituality, physicality, signification and artefacture. The work also of course demonstrates an awareness of still closer precedents, in twentieth-century School of Paris painters. But this again is to anticipate. For a

broader view of how David Jones arrived at the concerns, and the position within contemporary art history, implied in *Human Being* and *Portrait of a Maker*, it is necessary to backtrack.

* * * *

Whilst also a major literary figure, David Jones considered himself first and foremost a painter. In a letter to Harman Grisewood (the sitter for *Portrait of a Maker*) in 1938, the year after the publication of his epic of the First World War, *In Parenthesis*, he insists 'my equipment is that of a painter, not a writer'.[3] From early childhood, drawing was his constant occupation, and the only thing, it seems, he excelled at. A drawing of a bear, made when he was eight, was to remain one of his own favourite works to the end of his life. In 1910, aged fifteen, he went to Camberwell School of Art, conveniently local to his parental home in Brockley, South London. He attended Camberwell until the outbreak of war in 1914, and it was here that he began to think about the nature of art, which he describes as previously having been merely 'an accustomed activity and one which I supposed I should pursue later in life'.[4] After the war, he returned to art school, Westminster this time; but it was Roman Catholicism, discovered while he was a private in the trenches, and then fostered by friendships with such men as Eric Gill, or the charismatic Fr. John O'Connor, that offered the next clarification of his position both in art and life. In 1921 he was formally received into the Catholic Church. It is important to remember that at this time Catholicism represented a radical (even chic) cultural and intellectual ambience, which was quite as powerful and influential as that of, say, Bloomsbury liberalism. In Europe, and especially France, a Catholic cultural revival had been underway since before the First World War. Aside from numerous Catholic authors, major artists like Rouault, in the vanguard, or Maurice Denis, associated with an earlier, Post-Impressionist mode, commanded huge respect from proselytising critics like Jacques Maritain. England had its own formidable and attractive wing of this movement, including figures who were to become Jones's allies, such as Gill, Fr. O'Connor (G.K.Chesterton's Father Brown) and Fr. Martin D'Arcy of Campion Hall, Oxford.[5]

Very soon after he formally became a Catholic, Jones joined the Guild of St Joseph and St Dominic, in Ditchling Common, Sussex. This Guild was a lay community affiliated to the Dominican Order, which had grown up around Gill and the social theorist, craftsman printer and mime artist Hilary Pepler. These two natural leaders had moved, in 1913 and 1915 respectively, to a complex of farm buildings in

Ditchling that was to house 'a religious fraternity for those who made things with their hands'.[6] It is from his time here that Jones's first mature work dates, though of course it was to develop. Gill's strongly held ideas of the inadequacy of art detached from function – the importance of craft over fine art – influenced Jones in his first attempts at the Guild in the discipline of carpentry. He failed to master this, however, and developed instead the still acceptably craft-orientated skill of wood-engraving, illustrating some of the books for Pepler's St Dominic's Press. But the fine-art urge was obviously strong in him, and he returned to painting, as René Hague describes it, 'almost surreptitiously'.[7]

These relatively early paintings seem influenced by the stylised contours, simplified forms and cross-hatched tones of the engravings he was producing. Those vignette-like engravings have something of a primitive Christian look, recalling medieval manuscript illumination and Italian Gothic religious painting. Indeed, two murals done at Ditchling, one of the mocking of Christ (1922–3; Fig.1), the other of Christ's triumphal entry into Jerusalem, are very self-consciously in this archaising genre, both in what they are – wall paintings rendered over whitewash – and in their style and subject. Jones's awareness of modern painting was also showing itself, however. He had been introduced to Post-Impressionism by his teacher at Camberwell, A.S. Hartrick, who had worked in France before the turn of the century, and had known Van Gogh and Gauguin. Familiarity with a brand of Post-Impressionism more associated with Degas came through Walter Sickert, who had taught Jones at Westminster, and whose art Jones admired intensely. As far as Cézanne was concerned, Jones owned, probably from soon after its publication, Elie Faure's 1923 monograph on the artist, which was still in his library at his death.[8] He might possibly have had even more direct experience, before the First World War, of these and of still more vanguard figures in European art – Picasso, Matisse, Derain – at the Post-Impressionist Exhibitions organised by Roger Fry at the Grafton Galleries.[9] Thus it is possible to find echoes of Cubism and Futurism, and their English derivative Vorticism, mingling with the primitivism of Jones's works of the early 1920s (and in fact this specific stylistic conflation, it will be seen, is one which has close precedents in near contemporary Continental painting). The works anyway show a very modernist sense of paradoxical pictorial space. In *The Garden Enclosed* (1924; Fig.2), for example, the jutting path emphasises the flatness of the picture surface in opposition to the expected illusionistic recession. The exploration of pictorial space, pursued in ways more individual to himself, was to become a marked characteristic of Jones's work as it developed. Development was most obviously to take the form of a greater fluidity and movement, the early works from Ditchling being distinguished primarily by their angularity, density and visual

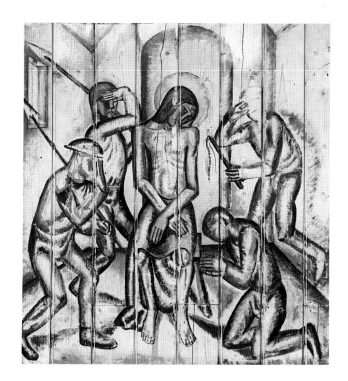

Fig.1 (Cat.3)
Jesus Mocked 1922–3
Oil on tongue-and-groove boards
112.1 x 105.4 cm

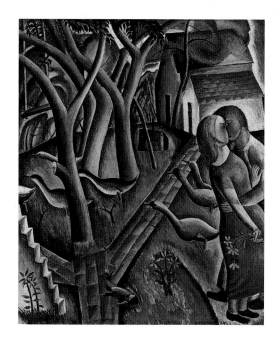

Fig.2
The Garden Enclosed 1924
Oil on panel
35.6 x 29.8 cm
Photo courtesy of The Trustees of the Tate Gallery
(not included in the exhibition)

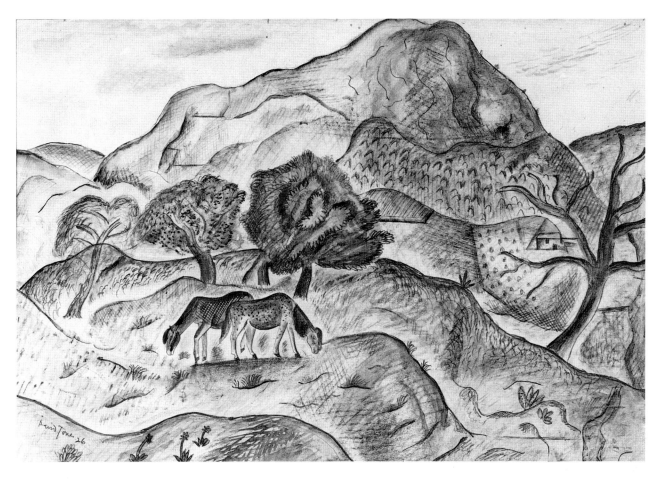

Fig.3 (Cat.16)
Hill Pasture, Capel-y-ffin 1926
Pencil, watercolour and chalk
37.5 x 54.6 cm

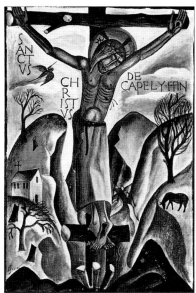

Fig.4
Sanctus Christus de Capel-y-ffin 1925
Gouache
19 x 13 cm
The Trustees of the Tate Gallery
Photo courtesy Edgar Holloway
(not included in the exhibition)

weight. *The Garden Enclosed* is, unusually for Jones, an oil painting, while other works of the period, though water-colour, still have the same overall apparent opacity and solidity. The ability to create solidity in this medium, often with the addition of non-transparent body colour, was always to be deployed by Jones, but far more selectively, contrasting such density with areas of open fluidity.

A break in the Ditchling community in 1924, essentially between the two forceful personalities of Gill and Pepler, led Gill to set up his own community at Capel-y-ffin in the Black Mountains of Wales. Jones followed later that year. From now on his paintings become much more numerous. The style is still less fluid than it would soon be, with pictures like *Hill Pasture, Capel-y-ffin* (1926; Fig.3) and *Sanctus Christus de Capel-y-ffin* (1925; Fig.4) continuing to share the tightness or dryness of his graphic art. But there is a dynamism and energy that marks Jones finding his form. The 'tightness' (a word that, he remarked more than once, is usually adverse criticism for a picture, favourable for writing) is not static but syncopated. It is notable that one Post-Impressionist whose greatness Jones acknowledged was Van Gogh, whose expressive dynamism in his mature period had evolved out of a cross-hatched, graphic style, inspired largely by quite academic popular Victorian wood-engraved illustrations, often sentimentally religious in imagery. Jones's own growth towards a personal expressionism had somewhat analogous stylistic roots. By the mid 1920s, pictures such as *The Waterfall, Afon Honddu Fach* (1926; Fig.5) and *Tir y Blaenau* (1924–5; Fig.6) strike one with their already vigorous synchronisation of composition. There is a correspondingly active light that moves, almost flashes through them.

Between this time and the early 1930s Jones painted at, among other places, Capel-y-ffin; his parents' home at Brockley; Caldy Island in the Bristol Channel, where he visited the Benedictine monastery; Portslade, near Brighton, where his parents rented a holiday home; the hamlet of Pigotts in Buckinghamshire, Gill's home after 1928; the South of France, which he visited with Gill; Rock Hall, Northumberland, the home of his patron Helen Sutherland; and London, where he visited friends regularly. Paintings of the sea, from Caldy and Portslade, are frequent, and develop most clearly the exploration of pictorial space. The title of one such work, *The Sea Wall* (1927), gives, as so often in Jones's work, a punning clue to spatial concerns: the sea itself reads as a vertical wall. *Out Tide* (*c*.1930–1; Fig.7), *Sea View* (*c*.1932; Fig.8), *The Terrace* (1929; Fig.9) and *Manawydan's Glass Door* (1931; Fig.10) similarly play teasingly with what is near and far, flat and recessive, deploying the device of a distant horizon viewed through the frameworks of open door and balcony, frameworks closely echoing that of the picture frame. The view through a window or door, from inside to

Fig.5 (Cat.17)
The Waterfall, Afon Honddu Fach 1926
Pencil and watercolour
55.5 x 37.8 cm

Fig.6 (Cat.18)
Tir y Blaenau Dec–Jan 1924–5
Pencil, ink and watercolour
57.1 x 38.1 cm

Fig.7 (Cat.30)
*Out Tide c.*1930–1
Oil on board
50.6 x 60.9 cm

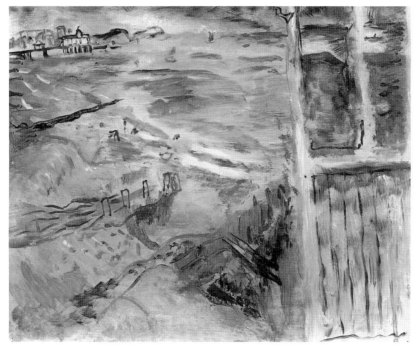

Fig.8 (Cat.29)
*Sea View c.*1932
Oil on board
48 x 58 cm

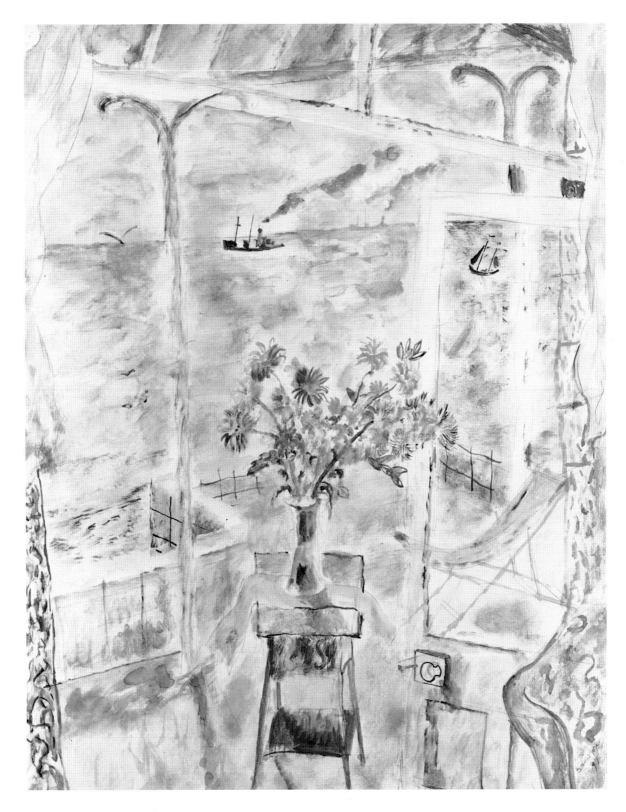

Fig.9 (Cat.31)
The Terrace 1929
Pencil and watercolour
63.5 x 48.9 cm

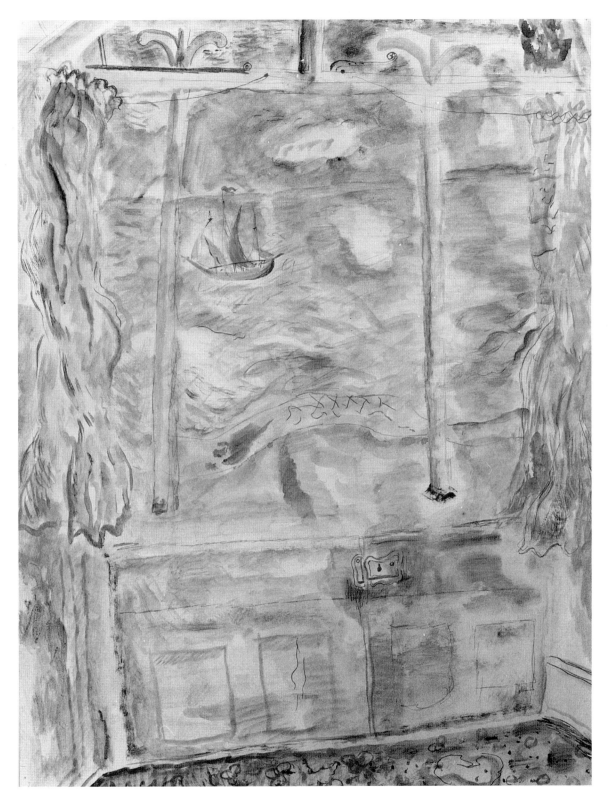

Fig.10 (Cat.33)
Manawydan's Glass Door 1931
Watercolour
63.5 x 49.2 cm

outside, near to far, is one which Jones was to adopt again and again (not least as he became increasingly reclusive, withdrawing later in life to the womb-like security of single rooms). Much of his work was done at Brockley, still very much his home base: interiors, and views onto the gardens nearby, as in *The Maid at No.37* (1926; Fig.11). An aspect of the artist's character brought out in these pictures, even in the titles alone (*Putting out the Washing, Dog on the Sofa*), is that of a whimsical, affectionate humour. René Hague recognised it as an aspect of the painter's personal demeanour, originating in his Edwardian suburban background – the world of Hilaire Belloc and the Grossmiths' *Diary of a Nobody*.[10] Along with this humour, however, there still exists a serious concern with the structure of paintings. Other titles of the period again hint wittily at aesthetic issues, such as *Suburban Order*, a painting which contrasts the 'order' of regular verticals and horizontals of garden fences with the informality of trees. *The Maid at No.37* similarly counterpoints the hard angles and parallels of architecture with the curvacious contours of the duster-waving maid and the boughs of the trees that wave around her. (Is there another pun in the title here, juxtaposing curves and straight lines in the two numerals 3 and 7?) Almost all Jones's work employs contrasts between static and dynamic elements, and he stressed more than once the necessity in art of movement:

> I know of no picture or other art work, if it is any good at all, that has not this feeling of not being stuck still . . . I don't care how static the subject is, but it must be fluid in some way or another. That is, perhaps, my criterion for assessing the worth of any picture.[11]

By the late 1920s, pictures like *Roman Land* (1928; Colour Plate 1) have a fully fluent handling. Jonathan Miles has regretted, in the latter picture, the inclusion of the 'Napoleonic barracks', without which he feels 'the picture vibrates' with greater energy.[12] But crucial for Jones is precisely that *contrast* between organic movement and architectonic stability; and increasingly essential, too, was the embedding of explicitly representational motifs, particularly ones of human construction, within abstract rhythms. The conjunction of the religious with the military, offered by the motif of a convent located in a former barracks, was also one which (as will become increasingly clear) Jones would have found irresistible.

* * * *

It was perhaps his desire for spontaneity and fluidity that led Jones to stay with watercolour as his primary medium, notwithstanding the few oil paintings already considered. He himself remarks upon the Englishness of watercolour, with the country's long tradition of artists working in that

Fig.11 (Cat.19)
The Maid at No.37 1926
Pencil and watercolour
40 x 28 cm

medium, and notes its linearity and immediacy, which may be taken as a personal preference expressed.[13] In fact, the medium saw something of a renaissance with many artists of his generation – Burra, Bawden, Hodgkins, Ravilious and others. Nevertheless, Jones's fidelity to a mode which sometimes commands less respect than the more physically substantial one of oil painting may have contributed to an occasional underestimation of his status as a modern painter.

It is appropriate to consider more closely here his position within modern European art in general. There has been a tendency to think of Jones as an isolated, even eccentric figure, relating only (and then only very temporarily) to English modernism. More recent criticism has partly corrected such a view, but there is still room for clarification of his particular affinities within the art of his time. From 1928 to 1932 he belonged, of course, to the Seven and Five Society, alongside Ben and Winifred Nicholson, Christopher Wood, John Piper, Henry Moore and Barbara Hepworth. He exhibited with them, with Eric Gill, with Ivon Hitchens, and alone, fairly frequently from around 1927. Naturally, too, Jones could have seen contemporary art books, and journals like *Cahiers d'Art*, and may have frequented contemporary exhibitions in progressive London galleries such as Storran, Zwemmer, Tooth and the Leicester Galleries. While Nicolete Gray, close to Jones, and herself an alert cultural observer, believed he had never been to Paris,[14] he had in fact accompanied Eric Gill there in 1927, when the latter visited Ossip Zadkine, very much a member of the French avant-garde.[15] Throughout his life Jones acknowledged the unavoidable influence of Picasso (he owned Maurice Raynal's 1921 book on the artist),[16] and at the Hampstead home of Jim Ede he had met Braque. Jones remained a consistent supporter of Bonnard's work right up to the latter's death in 1947, calling him 'my paragon'.[17] In 1945, when the British Council was preparing to exhibit works by Jones in Paris, he described the exercise self-depreciatingly, as being 'to show the inhabitants of Newcastle what coal is really like'.[18] When several of his paintings (including Colour Plate 1) were shown in an exhibition of British Contemporary Painters in the USA in 1946, the American critic and curator A.C.Ritchie immediately identified him with 'the decorative wing of the School of Paris, whose leaders are Matisse, Derain and Dufy'.[19]

Particularly significant here is the mention of Derain, a major figure up to the Second World War, whose influence, especially in England, has since been underacknowledged. Jones's paintings of the 1920s relate strongly to those by Derain of around 1912 onwards, and various of Jones's close associates, such as the patron Jim Ede, then at the Tate Gallery, and the private collector Helen Sutherland, were highly aware of Derain.[20] The important point in terms of Jones's relation to the Continental scene, is that Derain was at the head of a tendency in

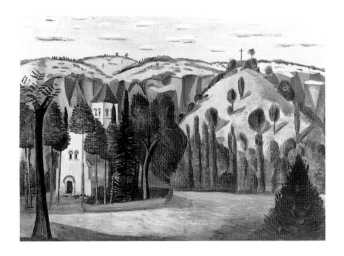

Fig.12
André Derain
The Church at Vers 1912
Oil on canvas
65.5 x 92.3 cm
Photo courtesy of National Museums & Galleries of Wales
(not included in the exhibition)

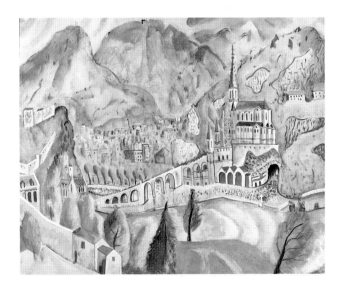

Fig.13
Lourdes 1928
Watercolour and body colour
48 x 60 cm
Photo courtesy of Kettle's Yard, Cambridge
(not included in the exhibition)

French painting which was actually in some senses, if not post-modern, counter avant-garde. Derain had abandoned the brightly coloured Fauvist style which had made him famous around 1905, and was creating paintings which in many ways sought a *rapprochement* with tradition. There was a widespread '*rappel à l'ordre*'[21] in France after the traumas of the First World War (traumas which Jones himself would seek to make sense of in modernist form, but through deeply traditionalist references, in *In Parenthesis*). Derain represented a recognition of how the formal devices of Cubism, derived from Cézanne (faceting, flattening of space, distortion of perspective), might be used not for ultra modern innovation and increasing abstraction, but as a reconnection with formalisations from primitive pre-Renaissance painting. This went hand in hand with a renewed interest in symbol and sacred subjects. Derain had produced a series of works, even before the war, in which still-life took on eucharistic overtones, figures and faces had the elongation of Byzantine saints, and landscapes featured the jumbled roofs of medieval art and were overshadowed by Calvary crosses (see Fig.12).[22] Portraits, too, were rendered as universalised, poignant encapsulations of human existence. Derain went on after the war to employ the gamut of traditional symbolisms and genres, making portraits which recalled Renaissance models, figure paintings suggesting antique murals, and still-lifes drawing on Dutch and Italian *vanitas* themes. He explored, also, alchemical symbology and astrological and esoteric lore. The significance of such a painter would have been clear for Jones, whose paintings of the early 1920s effect just the same elision of primitive Christian with Cubist traits. He, like Derain, would continue to seek ways to reconnect with a fullness of tradition, at both aesthetic and philosophical levels. Like Derain he would seek to do this in the face of a more universally accepted, reductive modernist logic that demanded progress toward ever greater literalism, purity of abstraction and materialist rationalism. Like Derain, again, Jones was not afraid to be thought anachronistic in the pursuit of his concerns, while being at the same time, in his own terms, highly conscious of the necessity to address the age. In the 1920s and 1930s he was in fact also in tune with a whole category of French artists which, while still consciously anti-academic, opposed the out-and-out avant-garde. This category was loosely termed, at the time, *Art Vivant*.[23] One can find works in which he is close to the quasi eucharistic still-lifes of Vlaminck, the pastoral landscapes of Segonzac, the urban and rural scenes of Filipo de Pisis or even Utrillo, the decorative interiors of Dufy, the spare nudes of Pascin and Foujita, the simplified portraits of Modigliani, and even the distorted ones of Soutine. Pictures like Jones's *Human Being* or *Portrait of a Maker*, for example, have stylistic traits which are very close not only to Derain but particularly to the last four artists mentioned.

* * * *

By the eve of the 1930s Jones was working towards a period of intense and prolific activity in which he painted pictures that he would always consider his finest, and in which his true concerns would emerge even more clearly. They are concerns which are fundamentally counter-modernist in their commitment to the figural in the widest sense, to the layering of metaphorical, historical, mythic and ultimately metaphysical meanings. The titles alone, which he gave to the new landscapes, seascapes, still-lifes and portraits, indicate his aspirations. They involve legends, as in *Manawydan's Glass Door* alluding to the Welsh myth cycle *Y Mabinogion*, or *The Chapel Perilous* (1932; Fig.14), referring to Arthurian tales. They sometimes have religious overtones, as in *Petra im Rosenhag* (1931), or as in *Briar Cup* (Colour Plate 4), *Thorn Cup*, or *Martha's Cup* (all 1932).

Cups, chalices, almost all types of receptacle, were for the painter evocations of the Mass. Their placement in the pictures is often centralised, their arrangement symmetrical, giving an added sense of symbolic moment. (*Hierarchy* [Cat.57] is the title of another still-life of the period.) When embellished with thorns or briars, the still-lifes have a multiplicity of allusion, suggesting the thorny crown, the enclosed flower garden, possibly even the fire that T.S.Eliot was to speak of, 'of which the flame is roses and the smoke is briars'. All trinkets, cups, condiments, scissors, nails, engraving tools, cloths, glasses, razors, pencils and the like were especially strong symbols for the painter. He was obviously drawn to them instinctively, but they hold rich connotations as the tools of his own trade of artist and printer. They speak, too, of the paraphernalia of the Mass and the instruments of the Crucifixion. Such items have a decorative, 'fancy' quality which seems to have attracted Jones; and an indication of the associative nature which they have for him is found in the language he uses in his theoretical writings on culture. He speaks, for example, of 'the enticements of Prudentia' with 'Her bright trinkets (which are never merely decorative, but always palladic and always of the nature of insignia) . . . which . . . may now seem to us no more than the amulets of superstition'.[24] We may wonder what religious and philosophical suggestions might have been raised in Jones's mind by many other qualities in the pictures so far mentioned: their ambiguous space; their inter-relatedness of composition; their poetry or rhetoric of forms; their emotive colours; their vital, infused light. Such a recurring feature as transparency (in glasses, water, windows, bottles) surely held particular correspondences. Any of these aspects in a picture may have some arcane connection or analogy, sometimes personal or idiosyncratic, sometimes more conventional. Jones's treatment of these things, while partly governed by pictorial and representational considerations, often indicates in its peculiar or lyrical or celebratory character, a subjective response to the meanings they hold.

One tentative speculation could be ventured as to an influence on the style of these works. The rhetoric of Jones's statement about Prudentia, quoted above, is consciously in the style of the Roman Catholic, broadly Thomist philosophers that he was reading from the time of his entry into the Catholic Church. He himself refers to 'the rhetorical expressions found in Maritain describing her [Prudentia again] as "Queen of Moral Virtues" and "born to command"',[25] and there are many such phrases in Maritain, or in Maurice de la Taille, whom Jones read deeply and described as 'my' theologian. Central to these writers' eloquence is the use of emotive adjectives to describe abstract concepts as having physical qualities. Maritain states of God, 'He spread over the world, like a table cloth, grace'.[26] De la Taille talks of the 'fruit of the Cross' or 'root of our sacrifice . . . glorious stem which bore the Eucharist',[27] and Maritain again of the 'Flower of the liberal arts'.[28] Certainly the manner of these writers coloured Jones's writing style, in poetry as well as prose. Surely they contributed in some analogous way to the particular rhetoric of his pictures.

It is widely recognised today that more is taking place in any 1930s painting by David Jones than a mere following up of the ideology of Post-Impressionism as preached by Roger Fry and Clive Bell – an ideology which, broadly speaking, led artists like Nicholson, Hepworth and others into abstraction. Few critics would any longer even mention, as Kathleen Raine did writing in the 1970s, that a viewer may 'mistakenly see him as an impressionist' and miss his 'fulness of allusion and implication'.[29] As early as 1947 Robin Ironside was grouping the artist among those who demonstrated that:

> It would be a mistake to infer that the ideas propagated by Roger Fry . . . ever exercised an exclusive influence, or that more mixed, more romantic tendencies than would have been suffered under that restrictive dispensation alone were not manifest . . . prior to 1939.[30]

Nevertheless it is important to avoid various associated dangers which arise if we are too eager to find the 'fulness of allusion and implication', and too sure as to what kind of allusions to expect. By conceding too readily some quasi religious content, the critic may overlook the difficult and necessary struggle of its manifestation. It was a struggle of which the artist was excruciatingly conscious, and in which he was never confident he had succeeded. There is something inadequate, therefore, in Robin Ironside's comfortable summary of Jones's endeavour:

> . . . in his most complicated works which are always his finest, the host of accessories seem to flutter together, to transubstantiate themselves one into another, in accordance, one easily feels, with the same miraculous laws whereby bread and wine change their substance at Mass.[31]

Fig.14 (Cat.34)
The Chapel Perilous 1932
Pencil and watercolour
48.2 x 61 cm

Secondly, one must not forget the strongly formal and material aspects which continue to dominate the paintings. If there is a level of meaning intended beyond the physical, it is achieved in and through the physical, not in spite of it. The artist was to assert that his metaphysical concerns were not by any means contrary to the seeming materialism of Post-Impressionist dogma. He records that he found Gill's riposte, 'Significant to what?' an unreasonable reaction to the doctrine of Significant Form.[32] His own position was very different from Gill's, which often tended to denigrate fine art altogether. Jones's philosophy of art is presented very fully in his essays 'Art and Sacrament' and 'Use and Sign',[33] and he enlarges upon it in much of his other prose and many of his letters. The sentinel point expressed time and time again is that the uniqueness of 'Man' among animals lies in the fact that he is a maker of things partially or completely independent of functional necessity; a human being is therefore an artist by definition. Of a piece with this artistic nature is humanity's religious nature. It is that freedom from service to the utile, allowing artistic activity, which also allows for the moral, mythological and in essence religious sense. Of the same order of signs which the artist makes, are those made by the priest. The works of both are sacramental. Man, Jones says, is:

A creature which is not only capable of gratuitous acts but of which it can be said that such acts are this creature's hall-mark and sign-manual . . . that man is unavoidably a sacramentalist and that his works are sacramental in character.[34]

And elsewhere he claims that:

. . . unless man is of his essential nature a *poeta*, one who makes things that are signs of something, then the central act of the Christian religion is totally without meaning.[35]

In short: 'No artefacture, no Christian religion.'[36]

It will be seen that in the light of these ideas at least one tenet of Post-Impressionism, that of art for art's sake, is quite in keeping with Jones's position. It is precisely the independence from function – the gratuitousness – that characterises art by his definition. It will also be understood how he found attractive parallels in other tenets of Significant Form, viz. that the work of art constitutes (like the act of the Mass) not a mere imitation of a reality but the creation of an equivalent reality. He records how as early as 1919 he had considered that in Post-Impressionist theory:

. . . the insistence that a painting must be a *thing* and not the impression of something has an affinity with what the Church said of the Mass, that what was oblated under the species of Bread and Wine at the Supper was the same *thing* as what bloodily immolated on Calvary.[37]

He recalls:

When I was at Westminster Art School in 1919–20 before I'd ever heard of Maritain etc. I used to say to chaps that I thought the theory of Post-impressionism, about painting and what not being a *thing* and not the impression of some thing, was analogous to what the Catholic Church maintained in her dogma of the Mass – they thought I was cracked (especially the Catholic ones!).[38]

There was no contradiction, then, between art's autonomous self-sufficiency and its metaphysical, even strictly religious character. Indeed, the *more* manifestly of the order of art a work is, the more of the religious order it also becomes.

Jones's religious/artistic theory is most succinctly put, however, not in any of his writings on the subject, but in his 1929 painting of his own workroom at Brockley, *The Engraver's Workshop* (Fig.15). Here the cross of the Crucifix on the wall is echoed in the cross handle of the engraving press (as well as in the cross of the window through which the artist observed his motifs). The tools of his trade on the table, in particular the bodkin-like engraving tools, hint at the accoutrements both of the Mass and the Crucifixion, events which are virtually symbiotic in the thought of the artist's favourite theologian de la Taille. The floorboards of the room are bare, as Jones liked to keep them, reminding him of a ship's boards: the artist's studio, like the upper room of the Last Supper, was a sacred vessel bearing the materials of ritual.[39]

* * * *

It is very common for artists to develop a rationale or a theory for what they do in their work. Frequently (and often fortunately) this creation myth has only a loose fit with what does in fact occur in their art. From simply looking very carefully at *Human Being* it was certainly possible to anticipate something of what has now been recounted of the intentions behind the picture. A similar scrutiny of other paintings of the period reveals the continuing impress of those intentions, but reveals also ambiguities and the potential for alternative, perhaps surprising interpretations. *Briar Cup* (1932; Colour Plate 4) is at first sight a tangled, vibrant field of marks, and the first response elicited may be an emotive one, a thrill at the energised 'abstract expressionism' of the surface. Making sense of the image as a representation only begins as specific, isolated details jump out: flower heads, a tea-cup handle, birds perched on a wall. Gradually these objects become clear and orientated – a central jug of flowers and brambles, a pepper pot, a cup, a coffee pot, a tureen. While they appear to float freely in the frame, they can all be discerned as sitting on a table top, beyond which are a walled garden, more distant moors, and the sky above. Items are still defined more by their details or parts than by their whole structures. It is the

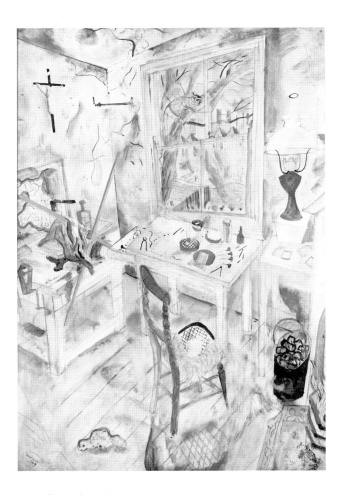

Fig.15 (Cat.22)
The Engraver's Workshop 1929
Pencil and watercolour
57.8 x 41.6 cm

individual thorns that mark out the stem of the briar. Of the various vessels, the handles are the most prominent and tangible bits, the parts on which we 'get a handle' visually. 'Handle' and 'tangible' are good words, for though the picture has the thinness of watercolour, pencil and ink (the artist's usual mixture of media), it is strongly tactile, both in the ways it contrasts textures – hard china, fragile petals, sharp thorns –and in the ways the 'touch' of the surface itself consists of dabs, scuffs and scratches. On a broader compositional level, these marks and textures are also marshalled into rivers of tonality and directional force, which flow through the work in rhythms often quite independent of the contours of objects depicted.

Colouristically, the picture has a pallid, salt-and-pepper complexion, and Jones is quite willing to ignore local colour almost entirely, sometimes dramatically so, as in the bright red reflection of the cup handle. Clearly, formal and pictorial concerns play a strong part in his decisions about hue, and about tone and the placement of incidents throughout the work: that orange-red reflection has to hook up to other reds in the picture, and to other arabesques. But the colour red, staining and pricking the surface, may also have an associative role, evoking, in conjunction with thorns, blood. Indeed, the red spout of the coffee pot, 'kissing' the tip of one thorn, becomes a formalised drop of blood. Here of course we are on the threshold of a whole world of possible connotations: Christ's crown of thorns; the cup in the garden of Gethsemane; the vessels of sacred food and drink with which the Christian religion has commemorated the Passion ever since. The picture may be inviting notions of nature – flora and fauna – as being divinely created in a way analogous to that in which human beings fashion pots or furniture (or paintings). Whether or not these readings operate depends entirely, as Jones was painfully aware, on whether such worlds of meaning are any longer part of the viewer's mental picture of the world.

There are other ways, though, of reading *Briar Cup*. Paul Hills has commented on the importance of eyes, frequently animals' eyes, in the pictures, and suggests that occasionally flower heads can also function like eyes, returning the viewer's gaze.[40] This is very much the case with the principal flower heads here, and it connects with a recurrent tendency in Jones to invest inanimate objects with animal or specifically human characteristics. In the present picture, for example, the coffee pot and tureen have a humorous animation, with their suggestions of arms, hands, feet and legs. Anthropomorphism can be implied, too, by the echoing of the forms of animate and inanimate things, as here perhaps in the fluttering of birds and the fluttering of delicate markings on a teacup. In the case of something as dominant as the 'stare' of the central flowers (and note also the ear-like form

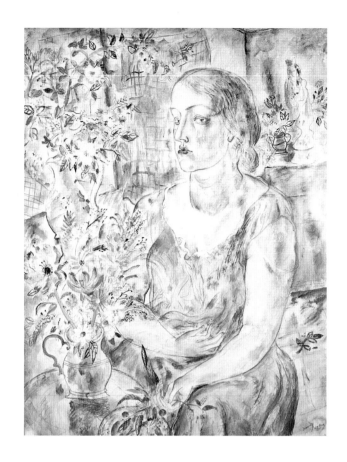

Fig.16 (Cat.12)
Petra 1931
Pencil and watercolour
63.1 x 49.2 cm

Fig.17 (Cat.11)
Lady Prudence Pelham 1930
Pencil and watercolour
59 x 45.7 cm

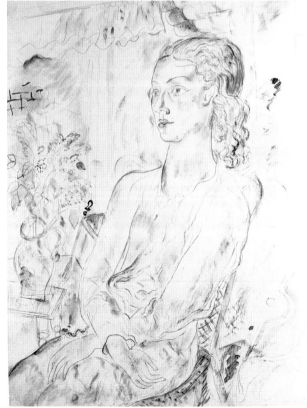

of the pot handle) the effect is of the whole gestalt of the motif – perhaps of the picture itself as artefact – becoming a living being. The inverse of the anthropomorphic equation of course is the proposition that living things can also be like artefacts. Thus the thorns of the brambles seem fashioned, and the structure of flowers contrived, just as the human artefacts around them (and the painting depicting them). Again though, for Jones, this association between artefacture and animation would provoke further contemplation of the way in which the ritual objects of the Mass become living things, and the manner in which all existence becomes specifically a Creation, orchestrated by divine intention. Again his fear would be that such resonances might be lost on his audience.

There are still other registers, however, other modes of knowledge in which factors like the artist's anthropomorphism can be understood as enriching his work. The French psychologist Jean Piaget has described the distinct phases of young children's developing consciousness of objects in their environment: there is a stage at which they conceive of all objects, organic or inorganic, as alive, as embodying an autonomous consciousness and motivation, like animals or humans; there is another stage in which children think of all beings, animal, vegetable and mineral, as the manufactured products of human beings.[41] For an adult looking at Jones's work, subliminal memories of childhood perceptions and ideas may well be brought into play. What is at times referred to in a general way as the artist's child-like style might well be touching upon specific, forgotten, and potentially psychologically loaded areas of experience. Thus, again, Paul Hills has connected the painter's pictorial 'play' with objects, to phenomena observed by the child psychologist W.P. Winnicott, occurring in the way children use toys as 'transitional objects' to negotiate a shift in orientation away from the withdrawing mother and towards the world beyond.[42] (Perhaps there is an unconscious acknowledgement of affinities with pre-mature states of mind in Jones's boyish 'self-portrait'.) Other aspects of his pictures are now open to new analysis in the light of modern psychology. In particular, the agitated physical methods of his image-making, his nervous line and tremulous touches of colour, invite epithets such as 'neurotic', 'obsessive', 'autistic', 'compulsive', 'therapeutic'. His own description of his technique was simply 'to make lines, smudges, colours, opacities, translucencies, tightnesses, hardnesses, pencil marks, paint marks, chalk marks, spit marks, thumb marks etc.'.[43]

When the expressionism, even the near-automatism, of his style is applied to an image of a human person, the psychological compound becomes fairly complex. For instance, in the various portraits of Petra Gill (eg Fig.16; 1931) one senses that the portrayal is not a detached one. We may or may not pick up the fact that the sitter is cast, in all sorts of subtle

ways, as Madonna, as Flora, as Matrix, as Primavera, as archetypal Woman. But over and above these intended tributes, there is undoubtedly the sense that the painter is almost compulsively subjecting her to the touches, affections, devotional fussings-over, bedeckings, sprinklings and stainings that are associated with a fetish object, either within a social cult, or within a private fixation. Also like a fetish object, the figure here remains serenely inscrutable, frustratingly unresponsive to the stimulations heaped upon it as upon a holy image which is desired miraculously to breathe, move, speak, bleed or weep. We are in a realm of meanings now which are beyond those directly intended by the artist. The expression of Petra can be seen as one of sullen resignation, contrasting strongly with the alert air in the male portraits of the time. *Lady Prudence Pelham* (1930; Fig.17) shows another feminine sitter, whose attributes are flowers, signifying beauty (as well as a pair of bellows, traditionally figuring passion), but whose expression is somewhat vacant and trance-like. The hands of these female subjects also appear inert and redundant compared to those of their male counterparts, who frequently have accoutrements of labour near at hand. Jones's feminine portraits, in other words, can come to seem like portrayals of the predicament of the female who has been made the object of patriarchal archetypal symbolisation.

Both Petra Gill and Prudence Pelham were important, of course, in David Jones's personal life. He had been in love with each of them at different periods – Prudence Pelham from around the time of the portrait, and Petra Gill in the 1920s, when she had become his fiancée (by the time of the portraits she had married someone else). Both relationships caused the painter much pain, as he was unable to establish a satisfactory liaison with either woman. The cause appears to have been partly to do with convention, since he could not imagine becoming a traditional breadwinner on his meagre earnings as an artist, and partly to do with his own psychological make-up. The thought of parenthood (a Catholic duty in marriage) was unimaginable to him, and the mature conjugal relationship generally seems to have been hard to face. Later, under psychoanalytical treatment, he admitted to a fear of sex and a deep-reaching evasion of any father-figure role.[44] In the case of the relationship with Petra Gill, it is not impossible that Eric Gill's sexual involvement with his own daughters may have created an especially intimidating association for Jones between the roles of father and lover.[45] Arguably, meanwhile, Jones was part of a whole generation of men who had in one very disturbing way lost their innocence, grown up, prematurely in the trenches of the First World War, but who by the same token had been left immature in other ways, deprived of a natural emotional transition from adolescence to adulthood. The infinitely revered (yet debilitatingly passive) symbolic roles imposed on women, not only in Western society in general but in particular in Jones's mythopoeic,

archetype-seeking mind, and still more particularly in the Roman Catholicism which so fed that mind, would all have contributed to his incapacity as a potential husband. The formulation he held to (fully aware that it might be seen as a rationalisation of emotional maladjustment), was that his profession of artist was in a strict sense a vocation, requiring celibacy. His inclination as a painter to see Prudence as the beautiful embodiment of a Christian virtue, and Petra as the Virgin in the Garden, precluded his being able to see them as his partners.

All these qualities and concerns, intentional and, as it were, super-intentional, in the works we have been looking at, are interwoven with numerous others in the vast series of major watercolours produced up to 1932. For these are hugely complex images, with ever-surprising resources of meaning, and they place their creator among the most considerable visual artists in Britain at that period. *The Translator of the Chanson de Roland* (1932; Fig.18), a portrait of the artist's friend René Hague, is another meditation on essential human faculties, notably sight. The sitter's eye, looking through spectacle glass, below a curtain of hair, is echoed in the window onto the landscape, beyond a blowing curtain. The same hand gesture that in *Petra* might have symbolised the womb, here imitates the slender lozenge of the eye. Once more in this picture, it is formal, visual features which first attract attention; but they are ones which can be read as clues to a comparison which is being proposed between the man and the man-made. The circles of finger nails and eye pupils repeat those of buttons and curtain rings; the contour of an ear is reflected in the curl of a collar; a shock of hair apes the shapes of rolled up shirt sleeves; the arm of a chair seems of the same substance as a human arm.

If eyes (and windows) are recurrent motifs, they are a reminder of how deeply, for all Jones's concern with metaphor and symbol, he is in love with actual perception. This is evident in *René Hague's Press* (1930; Fig.19), in some ways a pendant to the Hague portrait. Despite the softness of the architecture here, the bowl of space and the flood of light are given remarkable illusionistic realism. As in so many pictures, the picking out of details, and the corresponding loss of focus in the spaces around and behind each detail, is in its way a quite objective recording of the manner in which the eye sees. As frequently in Bonnard, what seems like (and what in effect may well be) emotive distortion, is often achieved through a quite disciplined attempt to denote a wide, fish-eye apprehension of objects in space.[46] Anthropomorphism recurs, almost too whimsically, in the animation of the machine into a kind of benign dragon, and again in the 'eyes' of the pair of diamond decorations on the staple of the press. This press is indeed a gift of a motif for Jones. With its lion's feet, lion and unicorn crest and ornate columns, it is the epitome

Fig.18 (Cat.13)
The Translator of the Chanson de Roland
(René Gabriel Hague) 1932
Pencil and watercolour
77.5 x 55.8 cm

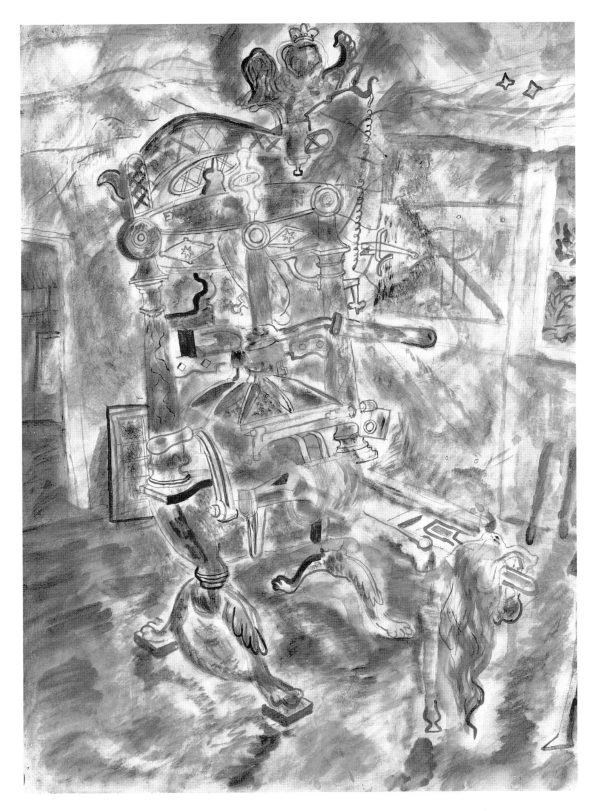

Fig.19 (Cat.23)
René Hague's Press 1930
Watercolour
63.6 x 48.3 cm

of function ornamented, a tool for the making of signs, which is itself a sign. The artist seizes on the way in which the assembly of parts, an entire still-life in itself (as well as being one portrait sitter which would really stay still), nevertheless continually betrays its potential for movement and articulation. There is the handle which winds the bed along the rails; the other handle, which lowers the platten and raises the counterweight when the press is pulled; the tympan and frisket, hinged open to the right (in a way echoed by the hinged open window beyond). This of course was the press on which 'the translator of the *Chanson de Roland*' would have proofed not only his English edition of the Old French epic for Faber in 1937, but also Jones's *In Parenthesis*. But as with all the artist's still-life objects, the concern here is to render the quiddity of the thing. He would have concurred entirely with André Derain's expressed ambitions at this time, to address what the medieval Schoolmen would have understood by the essential 'virtue' of objects.[47]

* * * *

Looking, then, in the 1990s, at David Jones's pictures from the early 1930s, what is evident is that aspects of his known concerns and intentions are certainly communicated. Some of the more specific references and more profound resonances which no doubt existed for him may be lost to us. But as if to compensate for this, new kinds of meaning, probably not anticipated by him, come into play – ones illuminated by psychology or by broadly sociological insights about gender. And it is interesting to note that at times in his writing on art the painter himself seems to glimpse and endorse the possibility that artworks accrue such super-intentional significances. Of a piece with his desire for formal flux came recognition that art must also have a flexibility of meaning. Even of his later works, in which, as we shall see, symbolism and minutely particular reference are employed in a dense fashion, he would stress that ' . . . none of this symbolism is intended to be at all rigid, but very fluid . . . many confluent ideas are involved . . . less explicitly intended than perhaps it sounds when written down . . . '.[48] He acknowledges that, while for the creator of a work of art very localised knowledge and intention may be operating, yet the critic or audience is 'concerned with the content of a work in a different sense altogether from the maker of it'.[49]

Nevertheless, through the 1920s and 1930s it is discernible that Jones suffered a growing anxiety about his inability to convey the real meanings he desired to express in his paintings. How does one paint still-lifes, landscapes, portraits, interiors and seascapes if one's concerns are with myth, religion and history? As he put it, 'If the poet writes "wood" what are the chances that the Wood of the Cross will be

evoked?'.[50] A solution that might come immediately to mind would be simply to make references more explicit. Indeed, the major illustration sequences that he undertook for *The Chester Play of the Deluge*, printed by the Golden Cockerel Press in 1927, or *The Rime of the Ancient Mariner* (see Fig.21), published by Douglas Cleverdon in 1929, must have afforded him some satisfaction in this respect. But the artist was acutely aware of the dangers involved in making such a move in his paintings. He continually emphasises the need, if signs are to be efficacious, to find a form which is valid for its age: works of art must have a 'requisite nowness'. And here we come to a central and overarching aspect of his ideas about art, viz. the acute feeling that his own epoch was fast running out of valid forms for those things which he wished to signify, and that this was indeed both cause and effect, to some extent, of the era's rapid loss of any sense of those things themselves. He felt, in fact, by the same logic that connected art with religion, that the modern age had no room for religion or genuine mythology, and no signs for them, and finally, therefore, no room for signs themselves. There was no room for artists, who, like priests, were 'Ishmaels in a diaspora'.[51] Like notions about the parity of culture and faith in general, ideas about the decline of Western secularised society, often derived from Spengler, were widely discussed among Jones's Catholic associates – men such as Tom Burns, or Christopher 'Tiger' Dawson (the historian whose encyclopaedic studies of world cultures formed a kind of academic parallel to Jones's much more creative chartings of the past). Everywhere that the artist expounds his philosophy, he refers to the problems of functioning in the mid/late twentieth century. His essay 'Art and Sacrament' is subtitled 'An Enquiry Concerning the Arts of Man and the Christian Commitment to Sacrament in Relation to Contemporary Technocracy', but he also deals with the problem in less portentous terms:

> If the painter makes visual forms, the content of which is chairs or chair-ishness, what are the chances that those who regard his painting will run to meet him with the notions 'seat', 'throne', 'session', *cathedra*, 'Scone', 'on-the-right-hand-of-the-Father', in mind?[52]

All the time, too, there was the nagging example of colleagues who, confronted with this general loss of signification, had turned to the 'nowness' of abstraction. He recognised it to be an attempted solution to just the quandaries he himself faced:

> Such questions and attempts to answer them are in part reflected in the preoccupation with the 'abstract' in the visual arts. This preoccupation, whether mistaken or rewarding . . . is determined by historic causes affecting all this whole business of sign and what is signified.[53]

In the face of scepticism from non-artists Jones was prepared to defend abstraction, as when he wrote a letter to

The Listener as late as 1950 supporting Victor Pasmore's departure from figuration. He even considered such a direction himself. William Blissett, visiting Jones in 1959, was told that in the 1920s and 1930s 'he was strongly tempted to go abstract . . . he concedes that the best work of the present age may prove to be in that mode'.[54] Non-figurative art was, after all, in some sense 'a map they could all understand', like the blank chart used by the sea voyagers in what is a highly important text for Jones, Lewis Carroll's *The Hunting of the Snark*. We have already seen, though, why finally he did not 'go abstract'. His conception of art for art's sake always required, in fact, a necessary external reference:

> I had views as to what a painting ought to be: A 'thing' having abstract qualities by which it coheres and without which it can be said not to exist. Further that it 'shows forth' something, is representational.[55]

Abstraction's evasion of the form/content 'problem', by claiming that the form *is* the content, was too simple. He was all too aware of the potential impersonality and sterility of rarefied pictorial manoeuvrings in non-figuration, a '"formalisation" of an extremely dull and depressing kind'.[56] He was also far too attached to the 'merely conventional signs' that the blank chart of Carroll's mariners so blithely did away with.

By the 1930s, indeed, David Jones was nurturing a massively elaborate and detailed mental map of themes, subjects, associations and influences within history, mythology, literature, religion, culture of all kinds. He longed to make more explicit the relation which he felt pertained between his own work and all of these things. He may even have felt that in employing seemingly neutral modernist motifs his pictures somehow conceded to or condoned the general decline of the sign. His dissatisfaction appears to have been not just at the level, either, of aesthetic conviction. Connected with this were private preoccupations, personal pressures building up below the surface of his work and seeking clearer expression. There was the ardour (and arduousness) which he had experienced of faith, of romantic love (to which *The Garden Enclosed* was his only overt artistic reference) and of a search for self, involving a passionate exploration of his own cultural heritage – not least his Welshness. But overwhelmingly the private trauma of his experiences in the trenches of the First World War cried out to be addressed. He was painting now on the eve of the nervous breakdown that was to strike late in 1932, almost totally preventing him from making pictures for the next decade. The nature of his neurosis has not been well recorded, but at times it took the form of an irrational fear of the very kinds of objects he normally delighted in (in a way which may corroborate our sense of psychological significance in his treatment of such motifs in his paintings).[57] It was severely exacerbated by attempts to paint, but by this time,

too, he had begun to write *In Parenthesis*, which would appear in 1937, describing his war experiences and, in a spectacularly convincing way, orientating them by reference to archetypal and antitypal coordinates from myth, history, literature and liturgy. Jones tells us:

> In 1927 or '28 in a house at Portslade near Brighton, from the balcony of which I used to make paintings of the sea, I began to write down some sentences which turned out to be the initial passages of *In Parenthesis* . . . I had no idea what I was letting myself in for.[58]

At the time of those first few sentences, writing itself must have seemed a parenthesis in painting:

> I began . . . with no other idea than to find out in what fashion these problems of 'form' and 'content' cropped up in the totally different media of written words.[59]

At the opening of *In Parenthesis*, in the first of many quotations which punctuate the text, the author gives a fragment of narrative from the Welsh legend *Y Mabinogion*, concerning Manawydan, who opens a mysterious sealed door which has remained hauntingly present through a period of peace and rejoicing:

> Evil betide me if I do not open the door to know if that is true which is said concerning it. So he opened the door . . . and when they had looked, they were conscious of all the evils they had ever sustained, and of all the friends and companions they had lost and of all the misery that had befallen them, as if all had happened in that very spot; . . . and because of their perturbation they could not rest.

In many ways it is the picture *Manawydan's Glass Door* (Fig. 10), painted from the Portslade balcony, which is Jones's swansong as a *sur-la-motif* painter. The usual foci of his interest – the potentially symbolic details of curtain rings, window catches, verandah curlicues, door-lock – are all pushed to the edge of the composition. The curtains are drawn aside like parentheses. The carpet pattern is confined to the lower margin, and reads like shingle, as the sea appears to flood with the light through the open aperture at the centre of the picture. The delicate masts, rigging and sails of the distant craft, tossing on the water, echo the posts, curtain cords and curtains of the vulnerable capsule from which the artist looks out. The paradoxical mood of the work comes from its combination of enormous charm and beauty with tragic frailty in the face of undefined disturbance, distressed surge.

* * * *

Although there are one or two paintings dated to the late 1930s, Jones did not return to pictorial work in earnest until

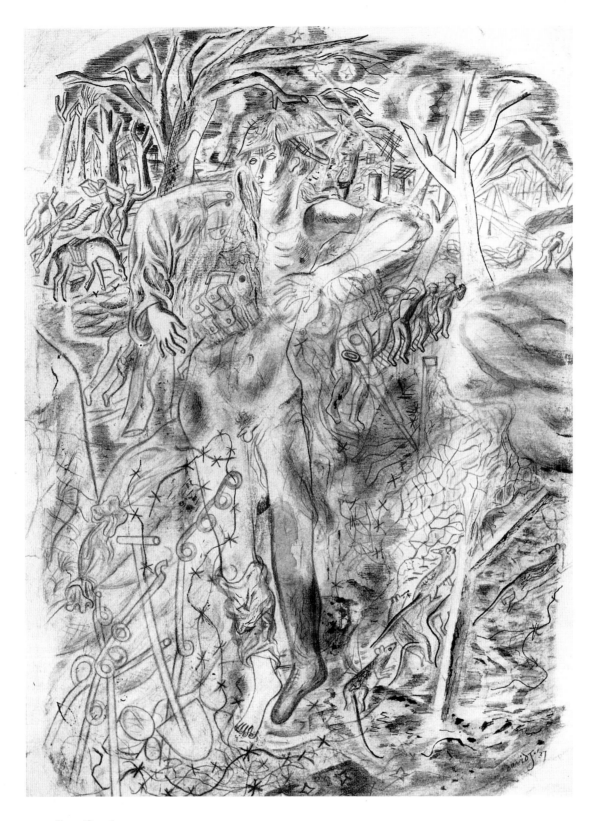

Fig.20 (Cat.36)
Frontispiece to *In Parenthesis* 1937
Pencil, ink and watercolour
38.1 x 28 cm

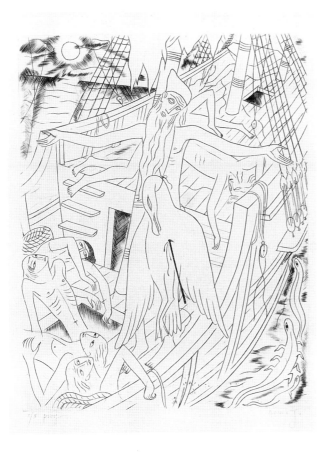

Fig.21 (Cat.8)
The Ancient Mariner with the Albatross hanging round his neck,
from *The Rime of the Ancient Mariner* 1929
Line engraving
17.5 x 13.7 cm

the early 1940s. Writing had become a major preoccupation, and after *In Parenthesis* he continued working on texts that were to become *The Anathemata*, another book-length free-verse poem, this time a highly abstract, trans-historical argosy in which his concerns with religion, history, nationality, language and culture were dealt with even more directly. The book was published, again to great acclaim, in 1952. Further fragmentary writings were to be published throughout the 1960s and 1970s, and even after his death in 1974. Many of these texts centre upon the Roman world and its relation to Christendom, and Celtic themes are also strong. Refined and developed further is a kind of social philosophy, even in broad terms a political theory, hinging on issues of ethnicity versus empire, and, of course, of rich, gratuitous signification versus the sterile, imposed utility and technocracy, which he saw as being now in the ascendant. The most telling sign of the times, for him, was still the death of the sign. What is striking, however, is that in such a climate he makes writings so defiantly teeming with symbolism, esoteric reference and allusion, while all the time acknowledging, as he puts it in the preface to *The Anathemata*, 'It may be that the kind of thing I have been trying to make is no longer make-able in the kind of way in which I have tried to make it'. Exactly the same goes for Jones's later pictures, when he finally returns to painting. He makes images which are unapologetically bristling with clearly mythological characters, historical narratives, specific signs, clues, cyphers and scraps of archaeological evidence. They are works which pick up on and extend the manner of his earlier book illustrations, particularly those to *In Parenthesis* (see Fig.20), but now such images are offered as autonomous pictures.

Among the first compositions in the complex new style are ones which draw upon Arthurian themes from Malory; notably *Guenever* (1940; Fig.23). This represents Launcelot's secret meeting with Queen Guenever as she tends the wounded knights of Arthur's court. The artist finds parallels in the two figures with Christ and the Virgin Mary. Launcelot's wounds are depicted as stigmata, and the suggestion of the Annunciation is also unavoidable. The sleeping knights are soldiers from the First World War (though equally they anticipate the shelterers from the Second World War Blitz as they were to be captured by Henry Moore). The sleeping dog, and the cat fleeing before Launcelot's crash-landing, are representatives of an animal kingdom for which the artist, who made many fine animal drawings at London Zoo in the early 1930s, always had a profound affection. Animals were the sharers of humanity's bodily existence, and in Paul Hills's phrase the 'trans-historical witnesses . . . to how then becomes now'.[60] From Jones's resonant repertoire of historic and cultural artefacts, meanwhile, come, in *Guenever*, the kettle and intricate hob device on which it boils. If the symbolism is made compelling and convincing in pictures such as

this or *The Four Queens* (1941; Fig.24), which illustrates the contest for Launcelot's love between four evil seductresses, it is by their formal dynamism. The works of this period all indicate the long struggle of their making, with continual adjustments, erasures and reiterations, and this gives them a new quality: opaque, dense, active, unified by an overall tone and movement. We may perceive the influence of El Greco's tonal dynamism and drama – fleeting highlights of supernatural illumination. We know that Jones admired the Spanish master's distortion and orchestration of form, being profoundly moved by his *Agony in the Garden* ever since it first appeared in the National Gallery in 1919.[61] The sleeping figures in *Guenever* evoke the sleep of the disciples in Gethsemane, and the chamber/chapel has the dream-like proportions and perspective of an illuminated subterranean cell – another image found in El Greco. The atmosphere in this picture, as in *A Latere Dextro* (c.1943–9; Fig.22), is very similar to that in a candlelit hall described in one of Jones's poetic fragments, 'The Sleeping Lord', into which we peer to observe ritual:

> in his timber-pillar'd hall
> (which stands within the agger-cinctured *maenol*)
> the tall, tapering, flax-cored candela of pure wax
> (the natural produce of the creatures labouring in
> the royal hives but made true artefact by the best
> chandlers of the royal *maenol*)
>
> > that flame upward . . .
>
> > under the *gafl*-treed roof-tree[62]

Perhaps this image, in both the poem and the pictures, originates with a candlelit barn of the Western Front into which the artist, when a private soldier, happened to peer through a chink, and where he observed, for the first time ever, Mass celebrated. (It was from that moment, he considered in retrospect, that he had become inwardly a Catholic.) Feeling increasingly that religion and art only survived in society in enclosed cells of some kind, he acknowledged the appeal of any image of enclosures, catacombs, preserves, soldiers' dugouts and so forth. Such were the enclaves of true culture, which operated now as a sort of sub-culture, protected from the inhospitably technocratic world outside. In life, his own fraternal 'billets' of the Ditchling, Capel-y-ffin or Piggotts communities had all been such havens; and now, after the death of his mother in 1937 (he had never really left home until then) he lived in a series of rented rooms or rooms in nursing or residential homes, where again he created refuges of culture and faith.

* * * *

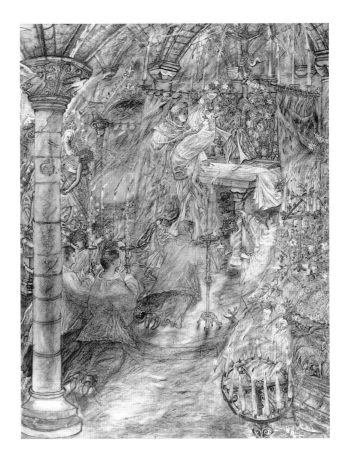

Fig.22 (Cat.5)
A Latere Dextro c.1943–9
Pencil, chalk, watercolour and body colour
62.2 x 47.6 cm

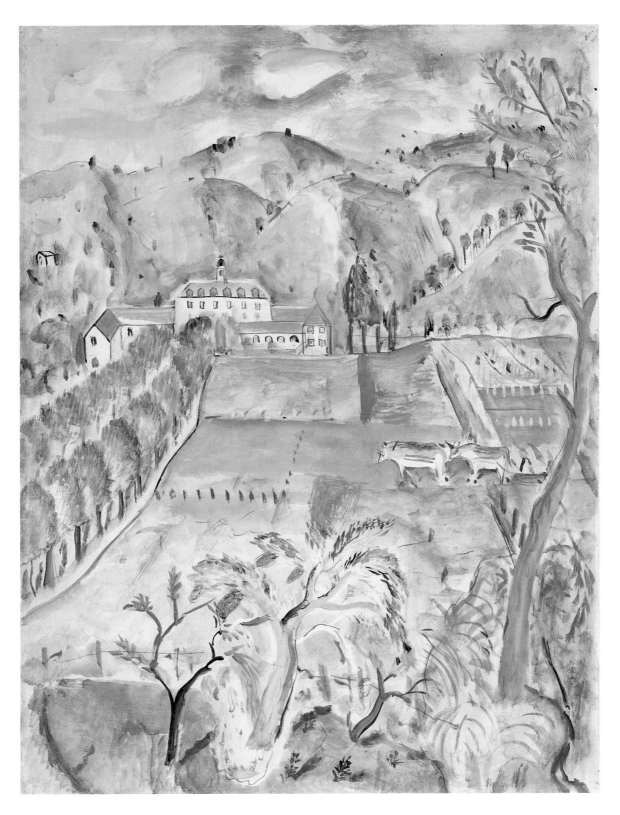

Colour Plate 1 (Cat.20)
Roman Land 1928
Pencil, watercolour and body colour
65.4 x 50.8 cm

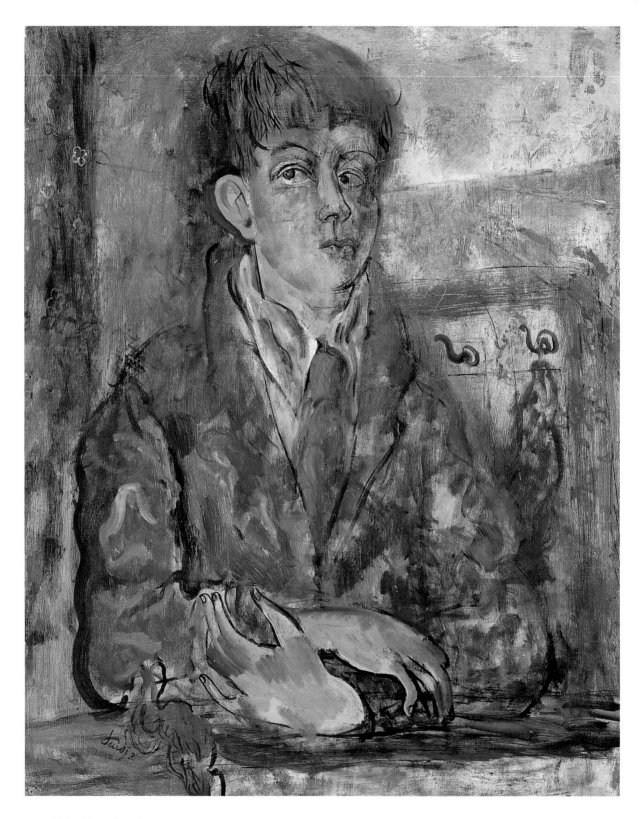

Colour Plate 2 (Cat. 1)
Human Being 1931
Oil on canvas
75 x 60.3 cm

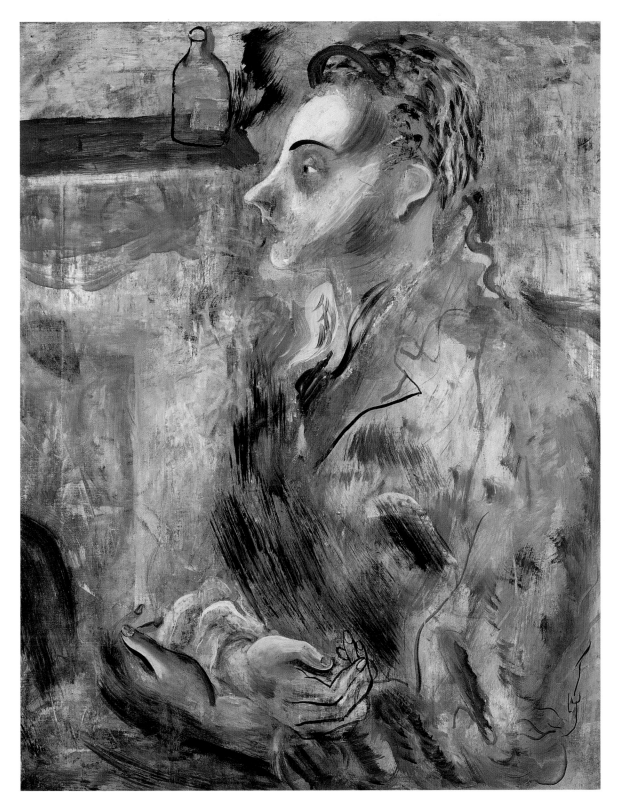

Colour Plate 3 (Cat. 14)
Portrait of a Maker 1932
Oil on canvas
76.2 x 61 cm

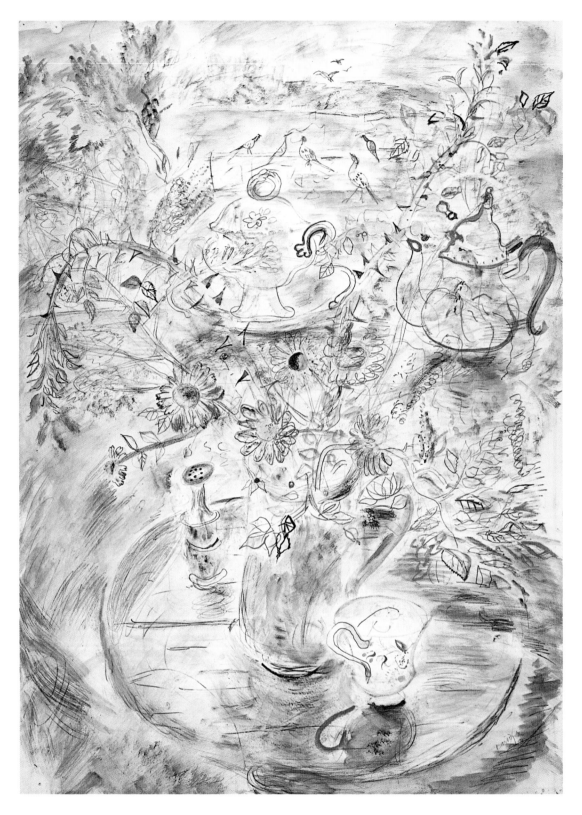

Colour Plate 4 (Cat.56)
Briar Cup 1932
Pencil and watercolour
76.5 x 55.2 cm

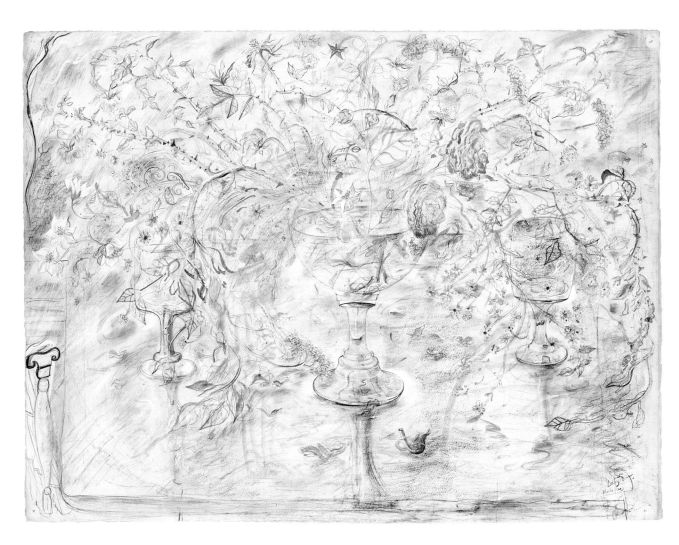

Colour Plate 5 (Cat.59)
Mehefin c.1950
Pencil, crayon, watercolour and body colour
57.8 x 77.5 cm

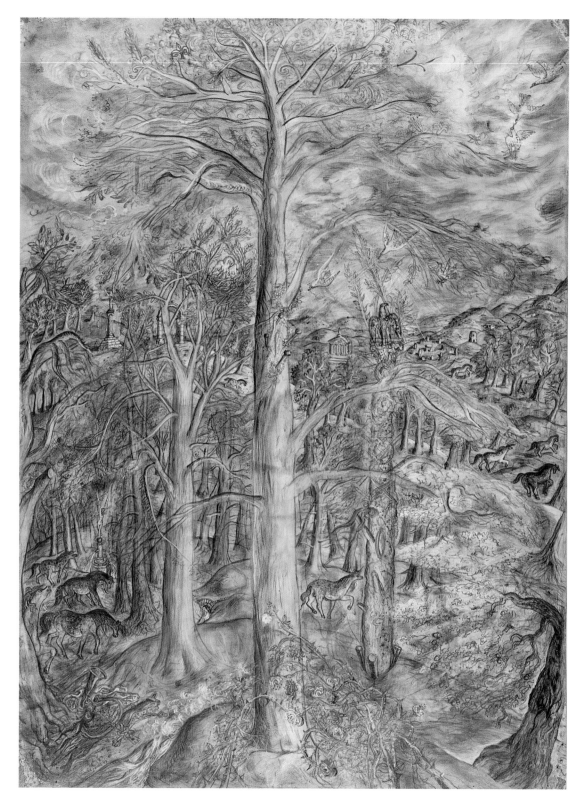

Colour Plate 6 (Cat.49)
Vexilla Regis 1947–8
Pencil and watercolour
75 x 55 cm

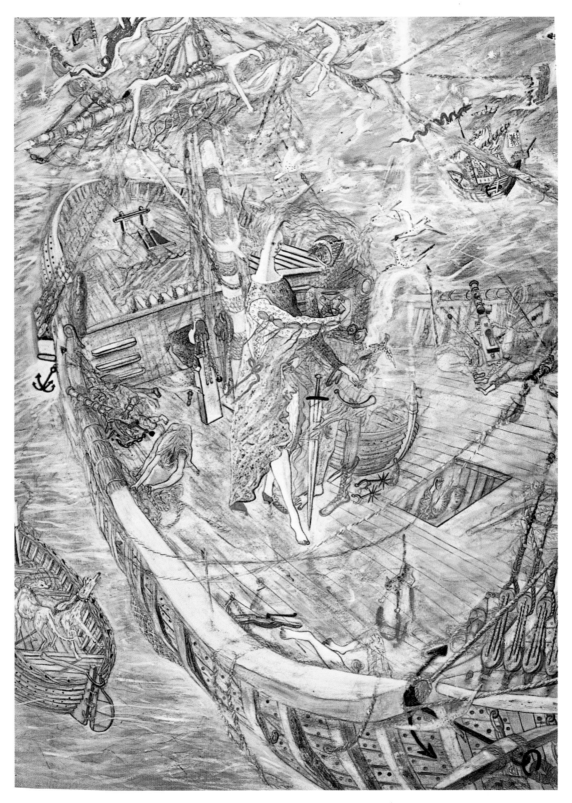

Colour Plate 7 (Cat.63)
Trystan ac Essyllt c.1962
Pencil, watercolour and body colour
77.5 x 57.1 cm

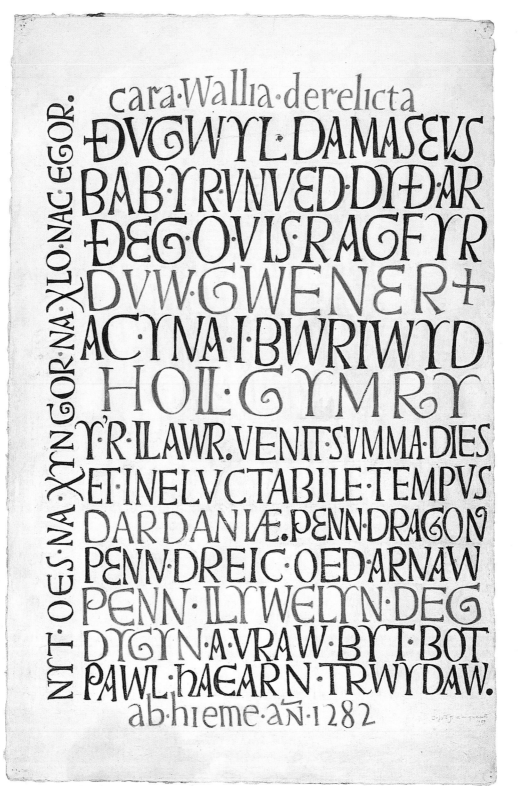

Colour Plate 8 (Cat.52)
Cara Wallia Derelicta 1959
Opaque watercolour on a ground of Chinese white
58.4 x 38.7 cm

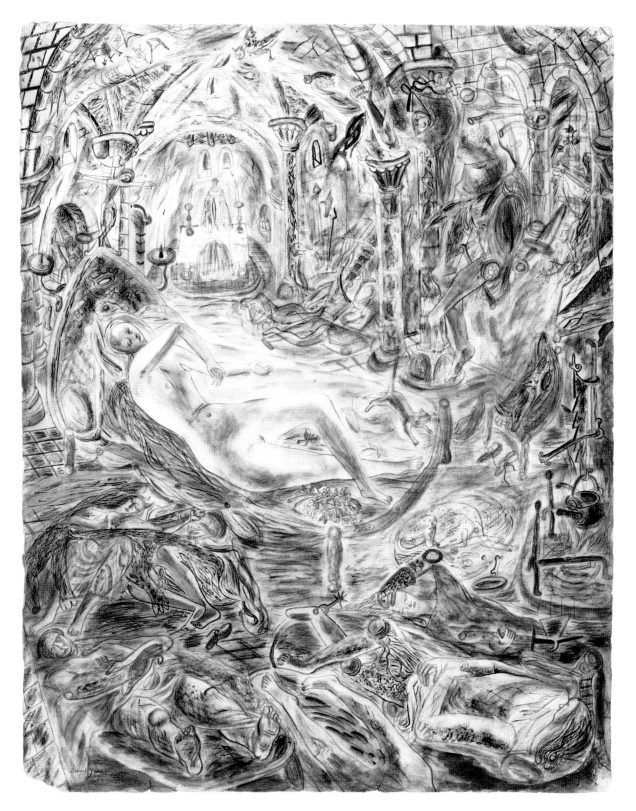

Fig.23 (Cat.38)
Guenever 1940
Pencil, ink and watercolour
62.2 x 49.5 cm

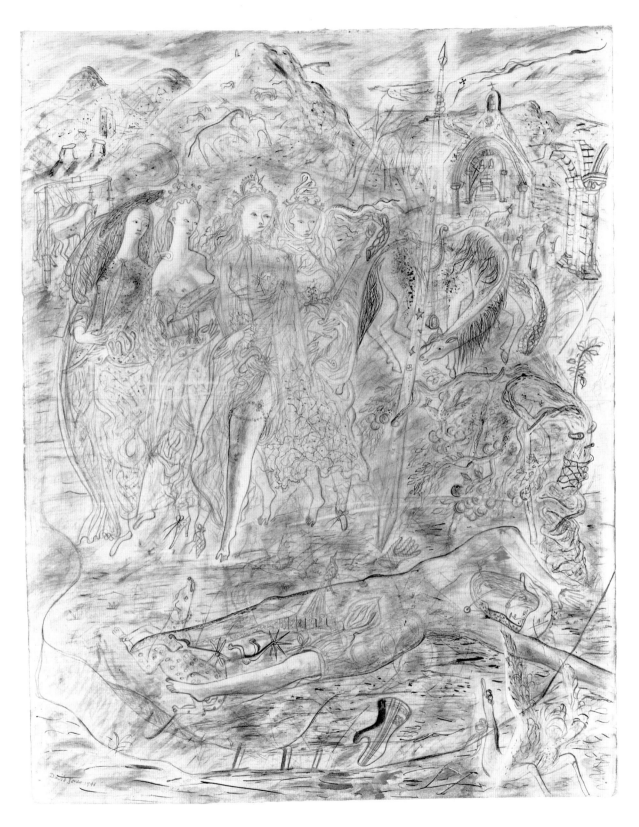

Fig.24 (Cat.39)
The Four Queens 1941
Pencil, ink and watercolour
62.2 x 49.5 cm

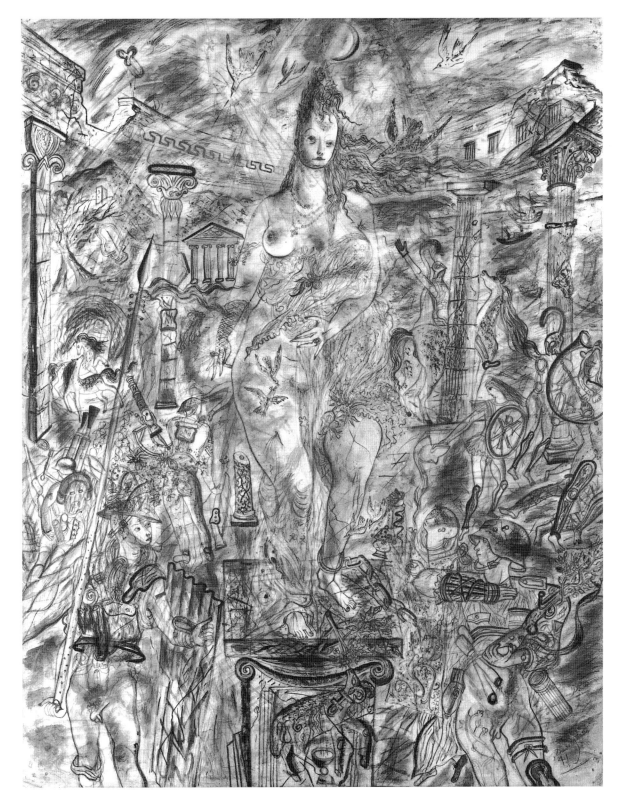

Fig.25 (Cat.41)
Aphrodite in Aulis 1941
Pencil, ink and watercolour
62.9 x 49.5 cm

One major subject for the later pictures is that of a feminine archetype. It was implied in the early paintings, and it is made more explicit in his writings, but now the ideal woman is depicted again and again, most notably in *Aphrodite in Aulis* (1941; Fig.25):

> . . . Aphrodite in the title was to include *all* female cult figures . . . all goddesses rolled into one – wounded of necessity as are all things worthy of our worship – she's mother-figure and *virgo inter virgines* – the pierced woman and mother & all her foretypes . . . [63]

The picture is full of Jones's preoccupations: the Grail, the Lamb, the soldiers (Greek and Roman, Tommy and Jerry), Doric, Ionic and Corinthian architecture, the moon, the stars and the dove. Again the most impressive thing is the vibrancy of surface, activeness of highlights and wiriness of contours, which have their emotive effect independently of (but associated by the artist with) the imagery. Among the later paintings there are also female figures more simple in design, such as in *Sunday Mass in Homage to G.M.Hopkins, S.J.* (1948; Fig.26), whose intended universality is conveyed through their emblematic simplicity and monumentality rather than the inclusion of detailed symbolism.

It has often been said, quite reasonably, that in his later work David Jones seems entirely unconcerned with any current trends in art. David Fraser Jenkins finds him placeable within, at most, a kind of tradition of anti-traditionalists among English artists whose work 'at least from their middle years, is quite unlike anyone else's and was not afterwards imitated'.[64] Nicolete Gray says that he 'lost touch with what was happening in art', and that, having earlier found a means of expression that was contemporary, 'like most original and important artists he ceased to bother about such problems'.[65] There are, however, some affinities between his post-1940 work and that of certain contemporaries. In general terms one might think of the painfully elaborate allegories of Francis Gruber in France, or the whimsical narratives of Stanley Spencer in England, or of certain extravagant fantasy pictures in late Kokoschka. Paul Hills has pointed to the relevance of Surrealism's erosion in Britain of the strong anti-narrative prejudices which had been fostered by the doctrine of Significant Form.[66] In particular one might cite figures on the periphery of European Surrealism, such as Wilhelm Freddie in Scandinavia, Leonora Carrington in South America or Paul Delvaux in Belgium. They all employ a strongly graphic style of spindly, cobweb complexity, applied to highly literary subject matter. Delvaux in particular enjoyed a vogue in England after the Second World War, and was admired (and largely imitated) by the painter and critic-curator Robin Ironside, who knew David Jones and wrote the first substantial study of his art in 1949. Like Jones, all the above-mentioned neo-

Surrealists mix archetypal or mythic references with very personal psychological – often sexual – preoccupations.

David Jones's psychiatric treatment, entered into in the 1940s, was Freudian, and he became very interested in and essentially convinced by psychoanalytical theory. It is intriguing to consider how he would have related notions of Freudian symbolism to the more traditional ones he himself was concerned with. Would he, for example, have reflected that his earlier paintings, the symbolic meaning of which he had despaired of conveying to their audience, may nevertheless have been operating upon the viewer in more subconscious ways? Another painter and aesthetic theorist of his generation, Adrian Stokes, who shared some of his artistic reference points (Cézanne, Bonnard), was certainly exploring such areas. Whether Jones was aware of such thinking is not known. His late pictures, though, done both before and after treatment, invite Freudian speculations in terms of their bizarre phallic distortions of the female form (specifically head and shoulders) as in *Aphrodite in Aulis*, or in *Y Cyfarchiad I Fair* (*The Greeting to Mary*) of 1963 (Fig.29) or *Trystan ac Essyllt* (*c*.1962; Colour Plate 7). Now more than ever female figures are like fetish dolls. Similarly, in *Aphrodite in Aulis* or *Epiphany 1941: Britannia and Germania Embracing* (Fig.27) stakes or pikes seem to operate as surrogate phalluses for the feminine characters. Sympathetic commentators have consistently underplayed what is, irrespective of the ultimate value of such works, their extreme perversity and high kitsch. What Jones's doctors thought of such paintings would be interesting to know, though psychological 'normality' and artistic excellence are of course notoriously uncorrelatable. We do know that *Aphrodite in Aulis*, which Jones was pleased with (unlike *A Latere Dextro*, which he felt he had overworked), was 'considered not psychologically balanced'.[67]

In 1947 the artist had had a return of his nervous illness. During the first bout, in 1932, he had been advised to rest from painting since it seemed to aggravate his condition. Now, however, psychiatrists (as opposed to neurologists) urged him to confront his neurosis *through* painting. Of one work, *Vexilla Regis* (1947–8; Colour Plate 6), he tells us:

> The psychiatrist, under whose care I was, *made* me go on, so that it was produced under rather special circumstances. (In a sense my doctor could be said to have been a 'part-producer' I feel.)[68]

Jones eventually considered it one of his greatest achievements, not just of personal endurance but also objectively judged as a work of art:

> . . . the *main* jumping-off ground was, I think, a Latin hymn we sing as part of the Good Friday liturgy in the Roman rite. Two hymns, in fact, one starting *Vexilla Regis*

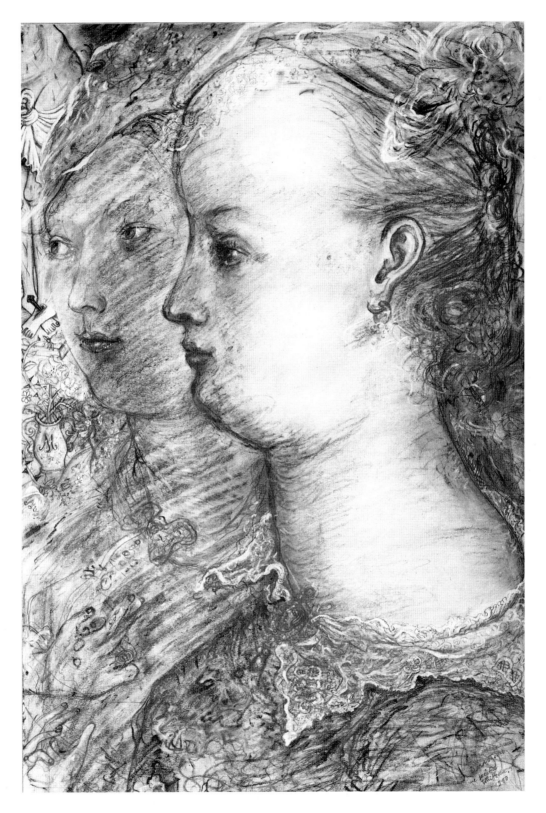

Fig.26 (Cat.45)
Sunday Mass: In Homage to G.M. Hopkins, S.J. 1948
Watercolour, chalk and body colour
55.9 x 38.1 cm

prodeunt, 'Forth come the standards of the King' . . . and the other starting *Crux fidelis inter omnes, arbor una nobilis*. This is a rather long hymn and in its various verses deals with the Cross as a tree . . . The general idea of the picture was also associated, in my mind with the collapse of the Roman world. The three trees as it were left standing on Calvary . . . The tree on the left of the main tree is, as it were, the tree of the 'good thief' . . . The tree on the right is that of the other thief, it is partly tree and partly triumphal column and partly imperial standard – a power symbol, it is not rooted to the ground but is partly supported by wedges. It is *not* meant to be *bad* in itself but in some sense proud and self-sufficient.[69]

It was about this picture that the artist specifically claimed that 'none of this symbolism is meant to be at all rigid, but very fluid', though whether this claim to openness of interpretation can be reconciled with the detailed key provided may be questioned. One is reminded of Blake, who said of his *Last Judgement* designs (not far from Jones's later pictures in density, detail and scale) that they were 'Not Allegory, or Symbolism, but Vision', whilst likewise providing a point-for-point 'explanation' of the images. But *Vexilla Regis* clearly aims for an exhilaration and majesty which precedes and incorporates more particular meanings. It aims to be a completely sufficient rendering of a tree – of, once again, the essential 'virtue' of the thing.

In 1962, when he had all but ceased to make pictures, the artist stated 'I doubt, personally, whether I, myself, shall ever do any half as good as I used to do in the 1930s, as far as painting is concerned'.[70] In 1940 he had observed, regarding Eric Gill's concern with concept over observation, that for British artists 'it is *the lyrical plus the observed* that has been, and is, most saving to the men of our common soil and mixed blood – we usually come a cropper with anything other'.[71] The 'lyrical plus the observed' well describes his own earlier works, and of the later ones he acknowledged 'I get into a muddle because I am really after the felicity of forms and their technical contrivance, but I tend to get bogged down with a most complex "literary" and "literal" symbolism at times'.[72] Occasionally in the 1940s he still produced the old mellifluousness of style when depicting directly observed nature. *Cumberland* (1946; Fig.28), is one of several paintings done at Helen Sutherland's last home, in Cumberland, in which the artist returns to pure landscape motifs, not unlike the views by Courbet or Derain that hung on his hostess's walls. There is also a series of tree studies (eg Cat.50) relating to *Vexilla Regis*, and, of a slightly different order, incandescent still-lifes such as *Mehefin* (*c*.1950; Colour Plate 5) and *Chalice with Flowers* (1949; Cat.61). In these, transcendence of the mundane materials of the motif is implied entirely through altar-like symmetry, ineffable luminosity and the dis-

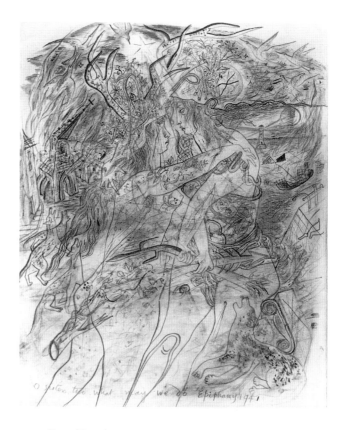

Fig.27 (Cat.42)
Epiphany 1941: Britannia and Germania Embracing 1941
Pencil, ink and watercolour
29.9 x 23.5 cm

Fig.28 (Cat.35)
Cumberland 1946
Watercolour
50.5 x 60.9 cm

tribution of particles of detail in an overall suspension. He still longed, though, for the intricate referentiality he had attempted in what he called his subject paintings. He sought 'complications and allusions but executed with the freedom and directness that used to be in my still-life and landscapes – that's what I want to do before I die'.[73] However, his last great attempt, *Trystan ac Essyllt* (c.1962; Colour Plate 7), was far from being produced with directness and freedom. It was in fact his most effortful pictorial achievement, and he abandoned one version when it became so physically overworked as to be virtually decomposed. He transferred the image to another piece of paper and brought it to a resolution. To Kenneth Clark it was the abandoned 'study' that remained more compelling,[74] and it is certainly a poignant document, testifying to how hard won (or hard lost) were, by now, the artist's expressions. The narrative and iconography of the work has been much discussed (it illustrates the disastrous drinking of the love potion in the well-known Tristan and Isolde myth).[75] What demands consideration is the significance, embodied in the unfinished version, of its near-collapse as a work of art. Insofar as it survives as a statement of an all-but-failure of coherence, this picture demonstrates *in extremis* a principle which pertains in all the artist's later work.

It is this problematising of the form/content resolution which is encapsulated again, though in a less fraught manner, in another branch of his later visual output, the decorative inscriptions he created through the 1940s, 1950s and 1960s. They take their texts from a range of sources: hymns, liturgy, scripture (in Greek, Latin and English) and Anglo-Saxon and Welsh poetry and prose. They frequently combine more than one of these. The method of production seems to have been a contemplative, intuitive one, often beginning with watercolour on Chinese white backgrounds, with little or no preparatory designing. Letter forms, word forms, and colours were manoeuvred (in conjunction sometimes with other symbols and decorations, such as crosses or stars) according to the demands both of abstract design and appropriateness to the sense of the words. When complete, the surface would often be burnished to unify the design, giving it rather the quality of parchment. *Cara Wallia Derelicta* (1959; Colour Plate 8) is a major example, a lament for the Welsh prince Llewelyn. The writing has a Celtic feel, with spiralling 'G' and 'Y' forms. The mixture of colours – black and ochregreen – and of languages – Latin and Welsh – seems fitting: sombre grandeur combined with earthiness. Here, as in most of the inscriptions, the forms of a certain letter – an 'A' or a 'D' – will be varied, sometimes within a single word.[76]

Jones said of his inscriptions, 'When they come off (and that's not all that often) they are much more satisfactory *to me* than most of my work'.[77] The reason why he could be so satisfied with them certainly had to do with the encapsulation they

offered of his problem of form and content. Content was on some level taken care of within the chosen texts, and he was freer than usual to concentrate on form. The inscriptions also unite many aspects of his other work. In manuscript, his poetry and prose frequently verges on the inscriptional, with colour used to emphasise words and make allusions. The inscriptions are also close to the paintings in technique, and it is worth noting that they lose as much or more of their tactile quality in reproduction. But again, crucially, these inscriptions are in dead, dying or endangered languages. They are languages which the artist valued passionately, although (and *because*) he himself had only a very partial understanding of them. The words are resonant, obscurely moving, vaguely familiar, but their primary impact on the vast majority of their audience is likely to be that of their strangeness, their distance from us. So once more these are works about their own condition as assemblies of virtually doomed cultural remnants, and the subject of *Cara Wallia Derelicta* – the destruction of Welsh identity – is appropriate for the grandest of these inscriptions. The artist's translation of the first and last lines was, 'Dear Wales all buggered up since the winter of 1282'.[78]

* * * *

Much as David Jones may have had a personal nostalgia for a notional past in which cultural coherence persisted, it is wrong to imagine that an ideal understanding of his work would involve a recognition of its every allusion, or that such an understanding would ever render transparent its essential opacity. T.S.Eliot, in his introduction to *In Parenthesis*, discusses the role of critical commentaries and authors' notes in elucidating obscurities in modernist works, and he concludes that the excitement of direct engagement must precede exegesis. This is true for all the later Jones, written and pictorial; and the justification for his obscurities could be made more strongly still. Denis Donoghue has said of the obscure quotations and citations in Eliot's own poetry:

> When Eliot gives . . . de Nerval's line from 'El Desdichado', 'Le Prince d'Aquitaine à la Tour abolie', it is not because he wants to send us off to consult de Nerval's poem or to speculate about the Aquitanian prince or the Tarot's broken tower, but because we are to be forced into a sudden sense of 'l'autre'. The more alien the line is the better. Nothing of its meaning in de Nerval, if we happen to recognise it, is excluded . . . but the richest attention is a sense of otherness.[79]

In a not dissimilar way, David Jones's work speaks of the 'otherness' of the whole of past and passing culture.

For he had not, after 1940, relinquished those imperatives he once felt about the necessary contemporaneity, the 'requisite

nowness' of all artists' images. He had not, as it may seem, chosen to lose himself entirely in his own anachronistic, antiquarian interests. The particular ways in which he deploys his symbolism, signals his cultural reference points, proclaims his affiliations, all amount in fact to a *statement* of what he saw as the tenuousness of the artist's project in the late twentieth century. Growing tortuousness of execution (as adequate abstract structure is sought, with almost too much protestation, for narrative detail) is one way in which the works announce a consciousness of their predicament. Another indication that they speak continually of their own near nonviability lies in the fragmentation that characterises all his post-1930s productions. It is most notable in the writings, in which the typical technique is one of collage and montage of partial quotations and half-forgotten precedents, assembled around a theme. It is very evident also in the late pictures, such as *Aphrodite in Aulis* or *Guenever*, with their scrambled mix of metaphors. The artist, indeed, felt a huge attraction towards broken or scattered things, from the early Welsh fragmentary poem *Y Gododdyn* (which he seems to have enjoyed precisely because its power shone through its incompleteness) down to the china on his own window-sill, which he is said not to have felt real affection for until it had been broken and repaired. (Domestically, Jones was a notorious breaker of things.) His phrase about Aphrodite being 'wounded of necessity as are all things worthy of our worship' reveals his conviction that damage was inevitable, almost desirable. The very title of *The Anathemata* was intended in part to denote damaged goods, rejects, obsolete cultural jetsam which nevertheless the artist makes the cornerstone of his creation. His statement in the Introduction that the kind of thing he had tried to make may be 'no longer makeable in the kind of way in which I have tried to make it' has often been recognised as overshadowing all his later works. And yet perhaps the more accurate statement here would be that his 'kind of thing' – richly cultural artefacts – may not be makeable *except* in the kind of way he has tried to make them. They are makeable now only as fragmentary entities, statements of a cracking-up, discontinuity and dispersal in the *materia poetica* that they attempt to reassemble. Peter Larkin, in a formidable discussion of Jones's relation to post-modernism, has offered, as an image of his mode of creating, that of a dry stone wall: each stone is a fragment which can never be reunited with its bedrock at the point of original fracture, but which finds its appropriate fit within a new whole.[80] *Map of Themes in the Artist's Mind* (1943; Fig.30) gives a strong indication of the organically accumulated synthesis which he could make from the very disorganisation of contingent knowledge and haphazardly assimilated culture. Indeed, the growing impression may be that he is paradoxically quite comfortable in the crisis which he so laments (like the private settling into his billet in *In Parenthesis*: 'It's cushy enough.'). He seems oddly at home as an 'Ishmael in a diaspora'. His cultural condition, which he likes to describe as so debilitating, can even be enabling. Thus in *Guenever* he is neither retreating into conventional Arthurian illustration nor into orthodox religious art, as in neither would Launcelot bear the stigmata. Jones is able creatively to associate such disparate symbolic elements precisely because they have in common a loss of currency.

It has been recognised, notably by Elizabeth Ward, that the artist's fixated and abstract idea of malign anti-cultural forces in the modern world can be somewhat simplistic, and is almost always unsupported by verifiable evidence.[81] His conception of externally imposed totalitarian uniformities, seeking to obliterate local, indigenous, familiar custom and culture, involves little recognition that faceless empires and orthodoxies have always themselves grown out of parochial prejudices and preferences. But we can understand perhaps that David Jones's art practice, in the end, *required* a sense if not of persecution or defeatism, certainly of marginalisation, of embattlement, of pursuance-in-despite.

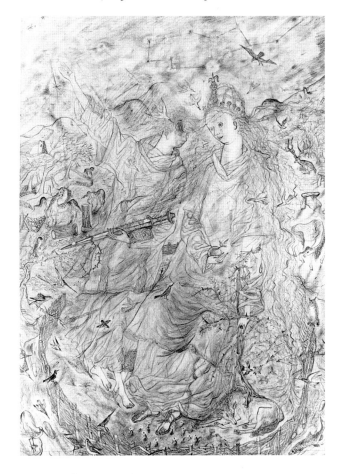

Fig.29 (Cat.64)
Y Cyfarchiad I Fair (*The Greeting to Mary*) 1963
Pencil, crayon and watercolour
77.5 x 57.8 cm

Fig.30 (Cat.7)
Map of Themes in the Artist's Mind 1943
Pencil, ink, watercolour and body colour
51.2 x 61.3 cm

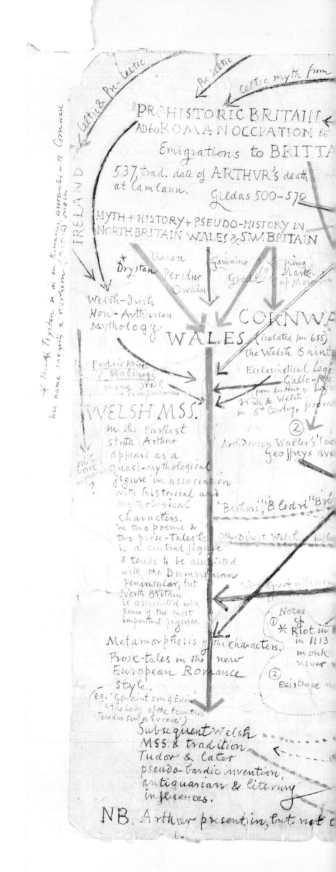

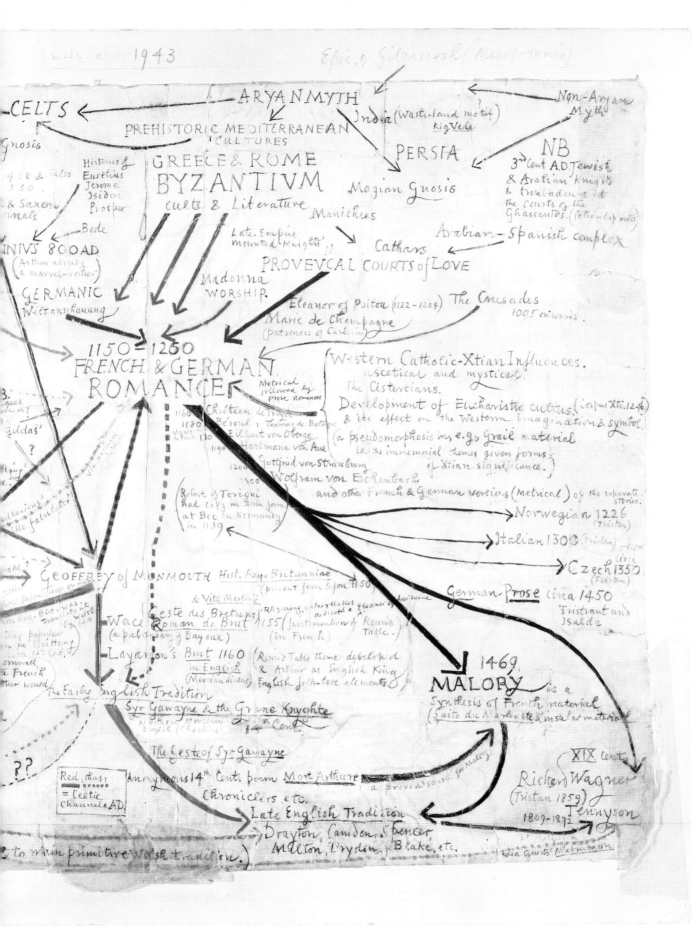

NOTES

1. Quoted in Paul Hills, *David Jones*, Tate Gallery, London 1981, p.96

2. See the artist's notes on the painting in the catalogue *Word and Image IV*, Douglas Cleverdon (ed.), National Book League, London 1972, Cat. No.75

3. René Hague, *Dai Greatcoat: A Self-portrait of David Jones in his Letters*, Faber, London 1980, p.83

4. Peter Orr (ed.), 'David Jones the Artist: A Brief Autobiography', in Roland Mathias (ed.), *David Jones: Eight Essays on His Work as Writer & Artist*, Gomer Press, Llandysul 1976, p.9

5. On Jones's Catholic intellectual circle, see especially Elizabeth Ward, *David Jones Mythmaker*, Manchester University Press 1983

6. Fr. Brocard Sewell, 'Hilary Pepler: 1878–1951', *The Aylesford Review*, Spring 1965 (a special issue on Pepler and the St Dominic's Press), p.10

7. René Hague, *Dai Greatcoat*, p.29

8. See Huw Ceiriog Jones, *The Library of David Jones: A Catalogue*, National Library of Wales, Aberystwyth 1995, p.102

9. In 1910 and 1912–13. In a statement for the *London Magazine* in 1961 (reprinted in David Jones, *The Dying Gaul*, Faber, London 1978, pp.41–9) Jones says, 'I seem to recollect a Post-Impressionist Exhibition round about 1912'.

10. René Hague, *Dai Greatcoat*, pp.25–6

11. Peter Orr (ed.), 'David Jones the Artist', in Roland Mathias (ed.), *David Jones: Eight Essays*, pp.11–12

12. Jonathan Miles, *Eric Gill and David Jones at Capel-y-ffin*, Seren Books, Bridgend 1992, p.149. Christine Mackay, of the National Museums & Galleries of Wales, has discovered, during conservation, that this work was at one time entitled, on the verso, 'The Convent of the Good Shepherd'.

13. 'An Aspect of the Art of England', in David Jones, *The Dying Gaul*, pp.59–62

14. Nicolete Gray, *The Paintings of David Jones*, John Taylor/Lund Humphries/Tate Gallery, London 1989, p.55

15. See Jonathan Miles, *Eric Gill and David Jones at Capel-y-ffin*, p.152

16. See Huw Ceiriog Jones, *The Library of David Jones*, p.237

17. For Jones's approbation of Bonnard see William Blissett, *The Long Conversation*, Oxford University Press 1981, pp.32 and 45

18. René Hague, *Dai Greatcoat*, p.130

19. Andrew C. Ritchie, *British Contemporary Painters*, Albright-Knox Art Gallery, Buffalo 1946, p.20

20. Still in the Jim Ede library at Kettle's Yard, Cambridge, is the English edition of the 1924 monograph on Derain by Carlo Carrà, one of the former Futurists who had turned to a classicising 'Metaphysical' style. Helen Sutherland, who owned two Derain paintings, recalled a trip to Paris in the 1920s: 'I dashed off to look for the Derain Gallery – I found it, Paul Guillaume, and saw at last some lovely lovely Derains...' (Nicolete Gray, *Helen Sutherland Collection*, Arts Council, London 1970, p.14).

21. For a background to this phrase, which had wide currency in France at the time, see Elizabeth Cowling and Jennifer Mundy (eds), *On Classic Ground*, Tate Gallery, London 1991.

22. Several publications on Derain were circulating by the 1920s, reproducing these works, and later ones such as *Le Gosse*, of 1920 (illustrated in André Salmon, *André Derain*, Paris 1923), bearing comparison with certain of Jones's paintings such as *Human Being* or *Portrait of a Boy* (1928).

23. It was promoted in the magazine of the same name, and others such as *L'Amour de L'Art* and *Formes*. *Art Vivant* is not widely discussed today, but see Christopher Green, *Cubism and its Enemies*, Yale University Press 1987

24. 'Art and Sacrament', in David Jones, *Epoch and Artist*, Faber, London 1959, p.146

25. Ibid. pp.145–6

26. Jacques Maritain, *Religion and Culture*, Sheed & Ward, London 1931, p.9

27. Maurice de la Taille, *The Mystery of Faith: An Outline*, Sheed & Ward, London 1930, p.36. Jones acknowledges his debt to *Mysterium Fidei* in *Epoch and Artist*, p.132.

28. At the time Sheed & Ward published the two above books, David Jones's friends Tom Burns and Christopher (Tiger) Dawson were both at the firm. Maritain's book was the first in the 'Essays in Order' series of which Dawson was contributing editor, and for which Jones engraved the Unicorn cover design.

29. Kathleen Raine, *David Jones and the Actually Loved and Known*, Golgonooza Press, Ipswich 1978, p.3

30. Robin Ironside, *Painting Since 1939*, Longmans Green, London 1947, p.14

31. Ibid. p.17

32. René Hague, 'The Clarity of David Jones', *Agenda*, Winter/Spring, London 1975, p.109

33. 'Art and Sacrament', in *Epoch and Artist*, pp.143–79; 'Use and Sign', in *The Dying Gaul*, pp.177–85

34. *Epoch and Artist*, pp.148 and 155

35. Ibid. p.13

36. Ibid. p.127

37. René Hague, *Dai Greatcoat*, p.232

38. René Hague, *David Jones*, University of Wales Press, Cardiff 1975, p.56

39. See Paul Hills, *David Jones*, Tate Gallery, London 1981, p.89

40. Paul Hills, 'Making and Dwelling among Signs'. Paper given at the conference *David Jones: Artist and Poet*, University of Warwick, April 1995 (publication forthcoming).

41. Jean Piaget, *The Child's Conception of the World*, Routledge & Kegan Paul, London 1929

42. See Note 40

43. David Jones in a letter to Desmond Chute about *The Anathemata* published in *Agenda* Winter/Spring, London 1979/80

44. René Hague, *Dai Greatcoat*, p.140

45. See Fiona MacCarthy, *Eric Gill*, Faber, London 1989

46. See the researches of Sargy Mann, most recently 'Pierre Bonnard: Painter of the World Scene', in *Bonnard at Le Bosquet*, South Bank Centre, London 1994

47. First quoted in 'Idées d'un Peintre', in André Breton, *Les Pas Perdus*, Paris 1924, pp.105–10

48. René Hague, *Dai Greatcoat*, p.151

49. Colin Wilcockson (ed.), *David Jones: Letters to William Hayward*, Agenda, London 1979, p.17

50. *Epoch and Artist*, p.120

51. René Hague, *David Jones*, p.28

52. *Epoch and Artist*, p.120

53. Ibid. p.121

54. William Blissett, *The Long Conversation*, p.13

55. *Epoch and Artist*, p.30

56. René Hague, 'The Clarity of David Jones', *Agenda* Winter/Spring, London 1975, pp.109–10

57. Nicolete Gray, *The Paintings of David Jones*, p.35

58. *Epoch and Artist*, p.30

59. René Hague, *David Jones*, p.9

60. See Note 40

61. René Hague, *Dai Greatcoat*, pp.21 and 118

62. David Jones, *The Sleeping Lord and Other Fragments*, Faber, London 1974, pp.76–8

63. René Hague, *A Commentary on The Anathemata of David Jones*, Christopher Skelton, Wellingborough 1977, p.38

64. A.D. Fraser Jenkins, 'An Interpretation', in *David Jones: Paintings, Drawings, Inscription, Prints*, The South Bank Centre, London 1989, p.12

65. Nicolete Gray, *The Paintings of David Jones*, p.55

66. Paul Hills, *David Jones*, Tate Gallery, London 1981, pp.48–9

67. René Hague, *Dai Greatcoat*, p.138

68. Ibid. p.151

69. Ibid. pp.149–50

70. Ibid. p.191

71. *Epoch and Artist*, p.294

72. René Hague, *Dai Greatcoat*, pp.137–8

73. Ibid. p.182

74. Kenneth Clark, 'Some Recent Paintings of David Jones', *Agenda*, Spring/Summer, London 1967, p.98

75. See for example R.L. Charles, 'David Jones: Some Recently Acquired Works', *Amgueddfa: Bulletin of the National Museum of Wales*, 22, 1976, pp.9–12

76. For an exhaustive study of this aspect of Jones's work, see Nicolete Gray, *Painted Inscriptions of David Jones*, Gordon Fraser, London 1981

77. Nicolete Gray, 'The Inscriptions of David Jones', in Paul Hills, *David Jones*, Tate Gallery, London 1981, p.127

78. Arthur Giardelli, 'Three Related Works by David Jones', *Poetry Wales*, Winter 1972, p.65

79. Denis Donoghue, 'Writing Against Time', in *The Sovereign Ghost*, University of California Press, 1976, p.229

80. Peter Larkin, 'Tutelary Visitations'. Paper given at the conference *David Jones: Artist and Poet*, University of Warwick, April 1995 (publication forthcoming).

81. Elizabeth Ward, *David Jones Mythmaker*, Manchester University Press 1983, pp.205–24

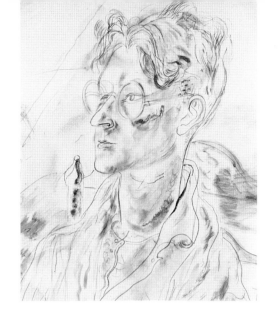

DAVID JONES REMEMBERED

THOSE WHO knew and supported the work of David Jones often established very particular relationships with him. Some of these were nurtured and valued by Jones for very idiosyncratic and precise reasons, the full picture of his network of contacts and interests only being pieced together later by those involved. For this centenary publication the National Museums & Galleries of Wales approached three people who knew David Jones to record something valedictory by way of a memoir. Arthur Giardelli, who continues as a distinguished artist with a studio home in south-west Wales. Nest Cleverdon, the wife of Douglas Cleverdon whose publishing enterprise opened up the possibilities of graphic art for Jones. Nest also acted in her own right as 'amanuensis' to David Jones ('copy typist' is too prosaic a term to describe her work on *The Anathemata*). And finally, the poet and writer Kathleen Raine, who has provided us with something of a summation of her thinking about Jones's work. David Jones's last inscription piece in 1968 was painted for her.

David Alston

Arthur Giardelli

At Bridgwater in Somerset in 1940, at an exhibition of watercolours, I bought a verandah picture by David Jones. On my return to Merthyr Tydfil where I was working at the Cyfarthfa Castle Grammar School, I wrote asking CEMA (the Council for the Encouragement of Music and the Arts – the forerunner of the Arts Council) to send a David Jones exhibition to Wales, from which I bought *Manawydan's Glass Door*. The works were inexpensive or I would not have been able to buy them. I wrote to David Jones asking about his paintings but had no reply.

Sometime in the early 1940s on Skomer Island, I met the painter Ray Howard Jones, who rebuked me for lighting a picnic fire there. I gave her a pot of honey and David Jones came up in conversation. I told her that I had received no reply to letters I had written to him. She offered to take me to see him in London. He came to the front door with three overcoats on, which he took off in the high ceilinged room upstairs where there was a large inscription over the mantelpiece and a view of Harrow with fields and trees to look down on. I asked him, after a while, why he had not answered my letters. He replied, 'I thought you would be some mid-European'.

Later it was mainly to the Monksdene Hotel in Harrow that I used to go to see him when I was on my way up to London from my home in Pendine. My knock on the door was answered in a sad voice. He would be wearing his yellow tie and looking sadly under his thick lids and straight low-hanging fringe. His mood would change through the whole gamut from grief to joy and glee. Conversation was easy and was shaped like his letters: there would be a main theme, incidental asides and asides on asides. He might start on an account of his visit to Jerusalem, recalling the ship's cat holding his stance on the sloping deck, which would take us to another cat and deck on which there stand Essyllt in her dressing gown and moment of triumph and Trystan clad for battle. Then he would take a portfolio leaning against the wall, open it, and show me *Y Cyfarchiad I Fair*, or *La Bonne Bergère*. He told me the story of its making and added, 'I don't think much of it, but I like the wolf'. He was distressed at his tearing of the large Trystan study but admired the craft of the mender at the Victoria and Albert Museum. He told me why he had made some of the pictures and recounted the stories they told. He reacted to criticism. He was annoyed by Kenneth Clark's comment that Essyllt was doll-like. Some doll! Knowing of my love for the story he gave me a small study he had made for the picture. He rejected the comment that the sleeping knights in his picture of Launcelot coming to Guenever were taken from Henry Moore. When I asked whether his views through a window were prompted by Matisse, he answered, 'I hate being out of doors'. He explained his difficulties in making the *Ancient Mariner* engravings. He had had little experience in engraving on copper and so had taken a lead from the Botticelli illustrations to *The Divine Comedy* where all is depicted in line with no shading. I have come to suppose that he had seen the drawings in a book that Clark had lent me when I was doing research on them. David commented on the precision of Dante's noting of time and place on that other journey.

At Monksdene I interviewed David for the BBC. 'Why', I asked, 'have you done so

many drawings of women: Mary, Essyllt, the Four Queens, La Bonne Bergère?'
'Everybody likes girls', he replied. Of the pregnant girl doing her shopping in Ken-
sington Church Street he explained: 'She passed in front of my window several times
while I was trying to write. I drew her so as to get her out of my mind.' At the end of
the interview he read *The Hunting of the Hog* in a hint of a Cockney accent, with
deliberate emphasis and calculated rhythm.

Perhaps it was Dylan Thomas who suggested to Stravinsky that he should see David
Jones when in London. When Stravinsky telephoned, however, Jones replied that he
never went out. But as Stravinsky was willing to visit him at home, David agreed. He
showed him some of his pictures and the musician said, 'I would like to buy that
one'. It was *Y Cyfarchiad I Fair*. But the artist replied, 'I don't sell my pictures'.

Through the medium of his art David Jones became able to see what he was looking
at. He came to know, as Chardin did: 'The eye needs to be taught to look at nature,
and how many have never seen and will never see her . . . ' Like a dancer stepping,
gesturing, changing pose and speed, David with his pencil and brush expressed the
movement of his mind. By means of his marks on the paper, a scribble, a scratch, a
wraith of pigment or flow of colour or firm running line, he observed and showed a
cow's back and the flick of its tail to drive off flies, the misty glow of evening, the
energy rising through a blackberry stem and the prick of a thorn. His pleasure in the
use of his craft makes what has been called the music and melody of painting. He
becomes aware that what he has revealed is, in the words of St Thomas Aquinas, 'the
corporeal metaphor of spiritual things'.

What he sees on the verandah at Portslade is Calypso's Prospect. The glass door of
the bungalow is Manawydan's glass door on the Island of Gwales and David as he
paints it is daring to open it onto his own life in the trenches. Petra is Flora and
Blodeuedd. The girl holding a foxglove in a sheepfold in the Black Mountains is
Lady of Heaven, Regent of the Earth and Empress of the Infernal Marshes. There is
no end to the investigation of those marks on the surface of Jones's pieces of paper.
In the practice of his art he found that physical metaphors are spiritual things, which
he found also when he took the bread at Mass.

What I have said here comes from my memory which is fallible, being sadly diluted
with time. What matters now are the writings and paintings.

Arthur Giardelli, June 1995

Nest Cleverdon

IN 1942 Douglas [Cleverdon] and I were living in a fairly disreputable club run by a lapsed society débutante, off Kensington Church Street. To his delight, Douglas discovered his old friend David Jones living in Sheffield Terrace, the very next road, so my first introduction to David was in the grubby crowded kitchen of our club, eating wartime cheese and potato pie and drinking very nasty Algerian wine. David was shy and not at all alarming; he seemed delighted to see Douglas again and to talk about old friends and how the war had changed the world for us all. He looked like Mole in *The Wind in the Willows* – that was the first thing I thought of – small, pale and thin, with hair cut in a fringe like Stanley Spencer, and a worried, abstracted look which, if you could make him laugh, relaxed into the most charming silent giggle. The fact that I was Welsh, with a Welsh name, seemed to give him pleasure, and we spent a long time discussing how to cook leeks; he was looking after himself at that time, with an inadequate open coal fire and one or two battered saucepans.

After the war we rented a tall, thin Georgian house in Albany Street, Regent's Park, and here after so long an interval, Douglas could once again hang the pictures he had acquired directly from David twenty years before: *Arcachon*, *The Long Meadow*, a marvellous nude, and some others. David was living in Mr Carlile's house at Harrow; he had a large first-floor room which he loved, and in which he did a good deal of work. Carlile's was a boarding house, like an up-market version of Dickens's Todgers's; the boarders were all male, ranging from Maurice Percival and Ronnie Watkins, both Harrow masters, to Stanley Honeyman, then a young man working for his exams. They all ate together at a huge Victorian dining table with old Mr Carlile at the head. We dined there sometimes as David's guests; the conversation was general and jovial, and I used to think to myself, 'Todgers's were going it!' It was a happy time for David; he made several lasting friends and was greatly loved.

He came up to Albany Street to dinner fairly often; Douglas usually fetched him and drove him back to Harrow in one of our ancient cars. Very often some of the huge Gill tribe would be in town for an exhibition or private view, and we would end up with a party at Albany Street. Once he came alone, and one of my children was busy drawing with a burnt stick which he had poked into the fire. David was envious, sent for some paper, poked his own sticks into the fire, and now thirty years later my son is the proud possessor of several drawings, done alas on the most terrible cheap lined paper in the most ephemeral medium of all. I always tried to cook something Welsh for him, cawl, roast lamb and leeks, *crempog las* (pancakes). The idea that Dafydd ap Gwilym and even Owain Glyndwr himself would have enjoyed the same food always pleased him, and he would happily take home a loaf of *barabrith*, or some Welsh cakes, cooked on a griddle.

To this period belongs the typing of the manuscript of *The Anathemata* which I did for him until pregnancy – more or less continual at that time – took over, and the job was finished by Ruth Winawer, Louis MacNeice's secretary and our lodger and friend. She and I agreed that it was quite the most difficult job we had ever tackled; not only was one supposed to follow religiously David's idiosyncratic spacing and

layout, but neither of us understood much of what we had to type.

Douglas, before the war, was a bookseller, and under the tutelage of Stanley Morison and Eric Gill, a publisher of finely printed books. In 1929 he had commissioned David's copperplate etchings for *The Rime of the Ancient Mariner*, by general consent some of his finest work. In 1938, the American slump having ruined the market, Douglas went into the BBC for a happy and productive thirty years, but in the early 1960s, with retirement looming, his thoughts turned once again to the book world which he had never really abandoned. With the superb work of the printers Will and Sebastian Carter, and some financial support from Louis Cowan, a rich, charming and devoted American fan, some of David's early work was republished to even higher standards. David and Douglas were both perfectionists, and a lot of fussing went on. Will Carter, wearing his printer's hat, made a special charge against Douglas, which came to be known as 'GBA' – General Buggering About. When the reprinting of *The Rime of the Ancient Mariner* was being discussed, David agreed to write an introduction, partly about the technique of copperplate etching, and partly about Coleridge. Years passed by, and we could not get him to finish it; it now concerned Latin poetry, early Welsh, and various other King Charles's heads in which David was passionately interested. In the end, money, expensively commissioned hand-made paper, and patience ran out, and Douglas had to persuade him to be allowed to print the first 1000 words – fortunately largely about technique – as an introduction to the poem, and the full essay of 15,000 words was published in 1972 as a separate, and fascinating, volume.

David, as he grew older and slower, still periodically prone to his old depression, hardly left Harrow in the last years, and not at all, of course, after his removal to the convent nursing home. He telephoned often though, and it seemed to be my job to cheer him up and perhaps make him laugh before passing the telephone to Douglas. It was not difficult; he loved to hear anything about Wales and there were various Welsh jokes which came in useful. His favourite, which never failed to send him off into silent giggling, was the story of the Bishop's Wife and Candidate for Holy Orders. It went like this:

Bishop's Wife (built on the lines of Mrs Proudie)
 Will you have a little more gooseberry TART, Mr Jones?

Mr Jones (straight from a Carmarthenshire farm)
 No, thank you, Mrs Hughes. *Goosseberries* goes through me like SHOTS!

I never knew anyone whose friends were so devoted, and so kind. Somehow we all took for granted that we would trail to Bond Street to buy special string vests, drive him to have his hair cut, chase up the art galleries who had cheated him, organise exhibitions, cope with his financial affairs, and all the other practical chores, just as one would for some beloved and slightly manipulative child. Louis Cowan gave me twenty-five dollars once to get a present for David; he thought he might like a new radio. But Dai's reaction was 'I don't want a bloody *machine*'. Months passed by, and then he telephoned one day and said 'I'd like a gold cup; I'd like to know what it would be like to be King Arthur'. But gold cups cost more than twenty-five dollars, and he was crestfallen. The next idea, more feasible, was a Jaeger dressing-gown. 'Some bloody woman took mine away and *washed* it, and she said it fell to pieces.' But even Jaeger dressing-gowns were too expensive at about £200, so in the end I bought just enough camel-hair cloth and made one for him which he used for the rest of his life.

Dai's most intimate friends, whom he loved and admired greatly, were certainly Harman Grisewood and René Hague; both Catholics, and both able to enter with passionate and scholarly insight into his most complicated thought processes. There were many other friends, both men and women, whom he liked to see and talk to, usually one at a time; very often it came as a surprise to find that someone one had known for years was also an intimate of his. Apart from straight friendship, some of them fulfilled a special function. Michael Richey was his tutor in all practical matters to do with ships and their rigging. For accurate archaeological knowledge he referred to Stuart Pigott. Many Welshmen did their best to help him with the Welsh language, but perhaps the most patient was Aneirin Talfan Davies.

Douglas, I think, was a practical friend. Among the innumerable poets, writers, musicians and artists whom he helped during his own long life, the nearest to his heart was David, and he looked upon it as a duty to make his work, both in writing and painting, more widely known in the western world. Hence his adaptations for broadcasting of *In Parenthesis* and *The Anathemata*. David didn't approve of either of them; he would have liked them to have been read aloud, very, very slowly and monotonously, by himself. Dylan Thomas and Richard Burton, both of whom acted in the production of *In Parenthesis* (who could forget Dylan reading the 'Boast of Dai'?) told Douglas that it was the greatest work in which they had ever taken part. The productions acted as an introduction to his work for many people who might otherwise have had no knowledge of it.

After Dai's death, Douglas began to work on a collected edition of as many as possible of his prints and etchings, to be prefaced by a long essay or survey. We scoured the country to find blocks and plates and had some disappointments but many more delightful surprises; a large clutch of early wood blocks was found in a cardboard box in the corner of the printshop at the Ditchling Press, and the copperplate which for years had propped up the leg of Dai's bed, which we at first thought was hopeless, was miraculously restored and made useable by Lallier, French printers who have been working in Paris since the eighteenth century. The resulting book, *The Engravings of David Jones*, was a source of great pride and pleasure to us, and to those innumerable friends who were only too willing to help.

Nest Cleverdon, July 1995

Kathleen Raine

I HAVE NEVER seen an explanation of a process (which those endowed with longevity can witness) by which the works of certain artists, once neglected or rejected, are later recognised and valued, while other works seem less significant than they once appeared to be. In the long run, what is authentic emerges from what merely reflects some passing fashion. The background changes and the ephemeral is forgotten – we get it right in the end. David Jones's *In Parenthesis* can now clearly be seen as the great work to have spoken for the generation of the First World War. There were others – Robert Graves's *Goodbye to All That*, and Erich Maria Remarque's *All Quiet on the Western Front* – better known because authors and public shared certain assumptions and attitudes which, however, may now be seen as transient. David Jones's work is rooted in timeless values. This was always recognised by a discerning minority: Eliot held David Jones to be one of the four significant writers of his generation, the others being Pound, Joyce and himself. Like Eliot's, David Jones's work is grounded in the history and teachings of Western Christendom and his affection for Joyce rested on Joyce's Catholic cultural and theological background in which David felt at home, but a world of which Joyce's secular admirers were scarcely aware.

David's work was rooted in three things which together defined for him his place in civilisation: Wales, and the Romano-British roots of his (and our) ancestral heritage; the Catholic Church and its liturgy, and especially the Mass, that timeless re-enactment of the death and resurrection of its founder; and the army. From his own experience of the killing-fields of France, as a young private soldier serving in the ranks of death with the Royal Welch Fusiliers, there is no doubt that David honoured the army, which he saw as one of the unchanging and profound realities of human life throughout history, from the Roman legions who guarded the frontiers of civilisation, to the Dais and Tommies of his own war. For David, pacifism was not to the point, but something deeper in the human condition, something sacrificial which, for him, only became comprehensible in the light of Christian teaching. This teaching, as he understood it, gives meaning to suffering and death, the inescapable extremes of our humanity. He became a convert to Catholic Christianity in response to his own experience of war in the trenches, where his contemporary, Herbert Read, abandoned religion. For Read, war made religion meaningless, and in a secular world his is the more superficially understandable response; yet I see David's as the more profound, taking, as it does, death into account in the balance of human values.

Future generations will read Jones's writings, and look at his great work as an artist, in a world far removed from his own, though one not perhaps without similar confrontations in some other form. As an artist he saw and painted the subtle, ephemeral beauty of flowers, as he did those poignant dead young soldiers, in the light of a sacramental vision of celebration and praise. His purpose was not to arouse fear and horror but to see in mortal beauty and its transience a reflection of eternal things. The flowers of the goddess of life spring from the graves of the dead soldiers of a thousand wars. 'Dai Greatcoat' sounded that mystery, which he saw as an eternal condition, in his own time and place, which his work seeks to consecrate

rather than to eliminate from this world of good and evil. In the security of Academia it is easy to take the painter's means for ends. I hope those to whom his work passes in the future will understand that his end and purpose as an artist was not that subtle technique, of which he was a master, but the communicating of a sacramental vision. That vision is an *anathemata* – an offering – 'a heap of all I could find' – a sacrifice of whatever our humanity can bring to the perpetual Mass offered on the altar of the world. It is this which inspired his work. It is this he had to say to future generations. David did not believe there would ever be an end to war, whether fought on the field of Roncesvalles, the Welsh battlefield of Catraeth or the trenches of the First World War. He tells us something of our humanity which we would no doubt rather not hear, of war as sacrament, evoking from men their dignity *in extremis*.

The Catholic world in which David moved was passing through what were to be the last days of a triumphalist church and a remarkable flowering of Catholic culture. His friends included Tom Burns, founder and editor of *The Tablet*, Father Martin d'Arcy, last of the great Jesuits of the Catholic aristocracy, Eric Gill and his community of artists at Ditchling, whose daughter Petra, David loved; the works of Jacques and Raissa Maritain were influential among David's friends. That world has also been depicted in the novels of Evelyn Waugh, Graham Greene and Antonia White: works destined to fall away with the world they depict, that context of Catholic culture which nevertheless sustained David Jones, but which at the end he felt had failed him. The replacement of the Latin Tridentine Mass by the vernacular after the Second Vatican Council removed what was most dear to his imagination. David was not a mystic, but a deeply religious man, his faith rooted in the teachings of the Church, in human history (that long retrospect, from the mammoth-bones to the events at Jerusalem at the time of the mystery of Jesus Christ's death and resurrection) and in the timeless anamnesis of the Mass. All those who, like myself, knew him (though I was never a member of his inner circle of friends) owe it to his memory to ensure that David's artistry, as writer and painter, is understood as a means to that end – to consecrate in the light of eternal values the breathing, suffering world in which his generation lived their lives.

I don't remember which of his friends it was who, commenting on the poky room at Harrow where he lived during his later years, looking out onto a car-park, observed that David still found it natural to live in a dug-out, as he had lived as a soldier in the trenches. If this was true, it was for reasons akin to the asceticism of the religious. David was not a renunciate by choice, but from a certain caste of mind, a sensitivity, rejecting a secular modern world that was deeply distasteful to him. When I visited him at Harrow, as I did from time to time over the years, his room was made beautiful by small treasures charged with meaning for him – his mother's silver teaspoon, a glass chalice in which he arranged the flowers he painted, a small knife, a slender pair of scissors, a photograph of the little dog Leica, sent up by the Russians into space. All these had for him that sacramental dimension which he sought for in vain in the increasingly secular surrounding world. At first he used to see me off at Harrow station, but in the end he could no longer bear to do this. The ugliness of a world without any sacred dimension, proliferating and submerging the landmarks of the soul, was more than he could bear. He retired into his dug-out where every small object had meaning and spoke to him of a 'real world' very different from what is so-called by the media-men, a real world in which, even on the field of battle, 'everything that lives is holy'.

Kathleen Raine, June 1995

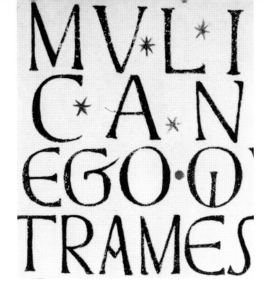

EXHIBITION CATALOGUE

Exhibition Catalogue

This list of works forming the centenary exhibition *A Map of the Artist's Mind: David Jones 1895–1974* has been compiled to reflect the layout of the exhibition. Chronology is eschewed in favour of themes. The opening section of the exhibition brings into play some of the many strands present in David Jones's creative life: a childhood drawing, a book presented by his father or a friend is juxtaposed with later many layered works. Startling ideas and motifs recur throughout his work, and can be found returning enriched, re-worked or simply repeated.

The information contained in this catalogue listing has been kept to a minimum. For detailed discussion of the iconography of individual works the reader is referred to Merlin James's essay in this catalogue and to the works listed in the Bibliography on p.72.

Measurements are provided in centimetres, height before width.

David Alston

The Artist

1 **Human Being**
1931
Oil on canvas
75 x 60.3
Private Collection
Colour Plate 2

Art in Relation to War

2 **Llys Ceimiad: La Bassée Front, 1916**
1937
Pencil, ink and watercolour
38.1 x 31.7
National Library of Wales, Aberystwyth

Llys Ceimiad: La Bassée Front, 1916 is exhibited with a sketch book Jones kept in the trenches (loaned by the Trustees of the Imperial War Museum), maps, his annotated regimental history and his 1937 text *In Parenthesis*. Jones annotated the section on Ypres in his copy of J.E. Munby's *A History of the 38th (Welsh) Division* thus: 'After recovery f[r]om my Somme wound in England, (at Shipston-on-Stour) I had leave and returned to the Battalion in the Boisinghe sector north of Ypres, late in October 1916. I was posted to 'D' coy and then later attached to H.Q. Soy which occupied dugouts on the banks of the Iser Canal. It was there that I met Fr. Daniel Hughes S.J.M.C. who lent me a book of St Francis of Sales. It was about this time that I began to be drawn toward the Catholic Church.' A photo of *Llys Ceimiad* in the Tate Gallery Archive has the following note by Jones on the back: 'May as well stick to this title. It has a point *Llys* means "palace" & *ceimiad* means "companion" & also a "champion" – and these are Welsh troops R.W.F., battle mates in a forward position near Givenchy, the *llys* or palace being the little dug out left bottom corner. In this area the trenches of the combatants were very close & meandered about at all angles.'

Faith

3 Jesus Mocked
1922–3
Oil on tongue-and-groove boards
112.1 x 105.4
National Museums & Galleries of Wales
(Only exhibited in Cardiff)
Fig.1

4 The Crucifixion
c.1925
Boxwood carving
11.4 x 7.6
National Museums & Galleries of Wales

5 A Latere Dextro
c.1943–9
Pencil, chalk, watercolour and body colour
62.2 x 47.6
Trustees of the David Jones Estate
Fig.22

The mystery of the Eucharist first impressed itself on Jones when, as a soldier in the First World War, he glimpsed through a crack in the wall of a barn the Mass being celebrated among soldiers at the Front. *A Latere Dextro* refers to this initial experience. It is exhibited here with a missal in which Jones has made a quick pencil sketch which informs the later image. In the missal his drawing of the elevation of the host is inscribed *Caldy, April 1927*, where he stayed with the Benedictine monks.

Also shown with *A Latere Dextro* are a copy of Eric Gill's *Christianity and Art* of 1927 (on loan from the Cleverdon Collection) with David Jones's monastic frontispiece; Paul Claudel's *The Tidings Brought to Mary* (1892), given to Jones in 1924 and in which he kept a childhood landscape drawing. A very rapid pencil sketch of a chalice relates directly to *Chalice with Flowers and Seal* (1950; Cat.60). Jones's still-lifes with limpid water and wild flowers in chalices explore the theme of transubstantiation, recalling the sacred vessel of the Catholic Mass. Frances and Ceri Richards gave Jones *Introduction au monde des symboles* by Gérard de Champeaux in 1971.

A Is for Artist

6 Artist's Worktable
1929
Pencil and watercolour
62.3 x 50.2
Private Collection

'My method is merely to arse around with such words as are available to me until the passage in question takes on something of the shape I think it requires and evokes the image I want. I find, or think I find, the process almost identical to what one tries to do in paintin' and drawin'. Having tried, to the best of one's power, to make lines, smudges, colours, opacities, translucencies, tightnesses, hardnesses, pencil marks, paint marks, chalk marks, spit marks, thumb marks, etc. evoke the image one requires as much as poss. one only hopes that some other chap, someone looking at the picture *may* recognise the image intended.'

David Jones in a letter to Desmond Chute about *The Anathemata* published in *Agenda*, Winter/Spring 1979/80

Artist's Worktable is shown with *A Is for Street Artist* – the first illustration for *The Town Child's Alphabet* (1924), with verses by Eleanor Farjeon, and other books which belonged to Jones, such as monographs and exhibition catalogues on Cézanne and Delvaux amongst others, and the treatise by Jacques Maritain, *The Philosophy of Art* (1923), published by St Dominic's Press in Ditchling. Michael Ayrton's anthology of *British Drawings* (1946) was a Christmas present from Prudence Pelham. Ayrton's text refers to the paintings of David Jones as 'a symbol of the continuity of tradition. They bear a strong family resemblance to the first colour plate in this book – not that they are archaic, but in their lyrical, linear freedom'. Plate I in the book is *Nimrod Sending out His Princes from Babylon*, a drawing in three inks on vellum (c.1000 A.D.), from a manuscript in the Bodleian Library. Jones has noted in the margin 'Jolly Nice'!

Map of Themes in the Artist's Mind

7 Map of Themes in the Artist's Mind
1943
Pencil, ink, watercolour and body colour
51.2 x 61.3
Trustees of the Tate Gallery
Fig.30

'I am in no sense a scholar, but an artist, and it is paramount for any artist that he should use whatever happens to be to hand. For artists depend on the immediate and the contactual and their apperception must have a "now-ness" about it. *But*, in our present megalopolitan technocracy the artist must still remain a "rememberer" (part of the official bardic function in earlier phases of society). But in the totally changed and rapidly changing circumstances of today this ancient function takes on a peculiar significance. For now the artist becomes, willy-nilly, a sort of Boethius, who has been nicknamed "the Bridge", because he carried forward into an altogether metamorphosed world certain of the fading oracles which had sustained antiquity. My view is that all artists, whether they know it or not, whether they would repudiate the notion or not, are in fact "showers forth" of things which tend to be impoverished, or misconceived, or altogether lost or wilfully set aside in the preoccupations of our present intense technological phase, but which, nonetheless, belong to man.

So that when asked to what end does my work proceed I can do no more than answer in the most tentative and hesitant fashion imaginable, thus: Perhaps it is in the maintenance of some sort of single plank in some sort of bridge.'

David Jones in a statement to the Bollingen Foundation, 1959

Map of Themes in the Artist's Mind is shown with related books from David Jones's library, a childhood drawing, *Edward [the Black Prince visi]ting Calais 1347*, made when he was aged ten, his student drawings of chivalric subjects (Tate Gallery Archive), an annotated Ordnance survey map of South Wales showing the distribution of long barrows and megaliths, an American comic strip version of the *Iliad*, and *Wounded Knight* (1930), a drypoint trial image for an illustrated version of Malory's *Le Morte Darthur*.

Place for Ships

8 The Rime of the Ancient Mariner
1929
With copperplate engravings by David Jones illustrating the poem by Samuel Taylor Coleridge. Published by Douglas Cleverdon, Bristol 1929. Printed by Ernest Ingham at the Fanfare Press, supervised by Stanley Morison.
Plate size 17.5 x 13.7
Cleverdon Collection
Fig.21

'If the voice of the water-floods and the cataracted foam resounds throughout this poem [The Rime of the Ancient Mariner] the same resounds throughout so much of our heritage-store.
 I suppose one of the commonest echoes of our childhood is the remembrance of hearing enclosed in little space the sea-shell's muffled echo of the limitless ocean's ceaseless surf-break … much as we may hold that the imagination takes off best from the flight-deck of the known, from the experiential and the contactual (I suppose the English proverb "Fact is stranger than fiction" has somewhere behind it something of this notion), the doubt … concerning the position of the vessel in no way interferes with what I take to be the main import of this poem, an import not unconnected with a passage somewhere in the Rig Vedic scriptures about the soul of us being sea-borne as in a vessel by him in whom is comprehended all that is.'

David Jones, from An Introduction to the Rime of the Ancient Mariner, 1972

As the grandson of Ebenezer Bradshaw, a mast and block-maker, Jones was to sustain a feeling for the sea and ships throughout his life. He saw here many metaphors and signs, but needed to underpin his poetic understanding with an armchair mariner's or shipwright's exactness. His friend Michael Richey, a sailor and navigator, was the source to whom he turned for seaworthy information.

The edition of Coleridge's The Rime of the Ancient Mariner (Cleverdon Collection), which Jones illustrated, is displayed in the exhibition with a childhood drawing of a cargo ship, The Severin, painted when Jones was aged twelve (Tate Gallery Archive) and a range of books, from a publication of 1945, How to Draw Sail and Sea by Michal Leszczynski, to technical manuals and Henry Frith's The Romance of Navigation. Against these are set two studies for the late work Trystan ac Essyllt (c.1959–62).

'The intimate creatureliness of things'

9 Farm Door
1937
Pencil and watercolour
73 x 50.8
National Museums & Galleries of Wales

The 'Door of little room at Pigotts with cattle outside and flowers etc.', which is how David Jones described the work Farm Door (1937), is shown with the animal drawings Study of Three Pigs at Capel (1926), Study of Stag's Head and Antlers (c.1930) and Study of Woman Playing with a Cat (1940s), all from the Tate Gallery Archive. Also shown are book illustrations for Aesop's Fables (1928) and The Chester Play of the Deluge (Cleverdon Collection), shown in the 1977 reprint published by Douglas Cleverdon.

Portraits

David Jones's interest in portraiture seems confined to the years 1930–32. It was a period of intense and fluent artistic activity preceding the first incidence of nervous breakdown for the artist in 1932, following on from the completion of the first draft of In Parenthesis. The portraits of the early 1930s depict members of Gill's community established at Pigotts. These portraits are not only likenesses but also auras of the people concerned; the titles convey attributes of the sitters, or generalisations about creativity as in Portrait of a Maker or the 'quasi self-portrait' Human Being.

10 Eric Gill
1930
Pencil and watercolour
61 x 48.2
National Museums & Galleries of Wales

11 Lady Prudence Pelham
1930
Pencil and watercolour
59 x 45.7
City Museum and Art Gallery, Stoke on Trent
Fig.17

12 Petra
29 August 1931
Pencil and watercolour
63.1 x 49.2
Glynn Vivian Art Gallery, Swansea (Gift of the Contemporary Art Society for Wales)
Fig.16

13 The Translator of the Chanson de Roland (René Gabriel Hague)
1932
Pencil and watercolour
77.5 x 55.8
National Museums & Galleries of Wales
Fig.18

14 Portrait of a Maker (Harman Grisewood)
1932
Oil on canvas
76.2 x 61
National Museums & Galleries of Wales
Colour Plate 3

15 Portrait of Desmond Chute
1932
Pencil and wash
60 x 47
Kirklees Metropolitan Council, Huddersfield Art Gallery

The Tutelar of the Place

There was always an association between artist and place in David Jones's landscape work. He painted landscape from his surroundings: his parents' home and suburban gardens in Brockley, South London, or the views from their holiday home at Portslade near Brighton; the landscape around Capel-y-ffin; trips to Caldy (Ynys Byr). At the end of the 1920s some landscapes produced in France attempted a more general sense of association with the Latin Mediterranean world of the imperium. A landscape painted at Rock Hall, the Northumberland home of art patron Helen Sutherland, takes on Arthurian connotations. Landscape could become a metaphor; it could also keep some things at bay, or bring home truths. A verandah picture could become the forbidden door of Manawydan which once opened (as it was for Jones during the drafting of *In Parenthesis*) led to 'an acknowledgement of all the world's losses'.

16 **Hill Pasture, Capel-y-ffin**
1926
Pencil, watercolour and chalk
37.5 x 54.6
Private Collection
Fig.3

17 **The Waterfall, Afon Honddu Fach**
1926
Pencil and watercolour
55.5 x 37.8
The Whitworth Art Gallery, University of Manchester
Fig.5

18 **Tir y Blaenau**
December–January 1924–5
Pencil, ink and watercolour
57.1 x 38.1
National Library of Wales, Aberystwyth
Fig.6

19 **The Maid at No.37**
1926
Pencil and watercolour
40 x 28
National Museums & Galleries of Wales
Fig.11

20 **Roman Land**
1928
Pencil, watercolour and body colour
65.4 x 50.8
National Museums & Galleries of Wales
Colour Plate 1

21 **Roland's Tree**
1928
Pencil, ink, watercolour and crayon
60.3 x 44.6
Private Collection

22 **The Engraver's Workshop**
1929
Pencil and watercolour
57.8 x 41.6
Private Collection
Fig.15

23 **René Hague's Press**
1930
Watercolour
63.6 x 48.3
Private Collection
Fig.19

24 **Jug of Wild Flowers**
1929
Pencil, watercolour and body colour
59.8 x 50
Casgliad Cyngor Celfyddydau Cymru/ Arts Council of Wales Collection

25 **Table Top**
*c.*1932
Watercolour
55.5 x 75.2
Austin/Desmond Fine Art

26 **Sussex Haven**
1927
Pencil and watercolour
38.5 x 56.7
Austin/Desmond Fine Art

27 **Vessels Sheltering**
1927
Pencil and watercolour
36.4 x 50
Casgliad Cyngor Celfyddydau Cymru/ Arts Council of Wales Collection

28 **Pleasure Steamer**
*c.*1931
Oil on board
48 x 58
Private Collection

29 **Sea View**
*c.*1932
Oil on board
48 x 58
Towner Art Gallery, Eastbourne
Fig.8

30 **Out Tide**
*c.*1930–1
Oil on board
50.6 x 60.9
Manchester City Art Galleries
Fig.7

31 **The Terrace**
1929
Pencil and watercolour
63.5 x 48.9
Trustees of the Tate Gallery
Fig.9

32 **Eisteddfa Calupso (Calypso's Chair)**
1931
Pencil, ink and watercolour
49.7 x 60.4
Casgliad Cyngor Celfyddydau Cymru/ Arts Council of Wales Collection

33 **Manawydan's Glass Door**
1931
Watercolour
63.5 x 49.2
Private Collection
Fig.10

34 **The Chapel Perilous**
1932
Pencil and watercolour
48.2 x 61
Private Collection
Fig.14

35 **Cumberland**
1946
Watercolour
50.5 x 60.9
Trustees of the Cecil Higgins Art Gallery, Bedford
Fig.28

History and Romance

David Jones had an ambition, detectable from childhood, to be an illustrator of Welsh history and legend. In his student days, against the background of high Victorian historical realism, moving from imagining the stories and histories to illustrating them probably appeared a fairly straightforward exercise. But in maturity Jones developed a complex and multi-layered sense of history and myth and their interrelationship. He became more interested in the signs and metaphors embodied in these stories and their vestigial survival into the present.

36 **Frontispiece to** *In Parenthesis*
1937
Pencil, ink and watercolour
38.1 x 28
National Museums & Galleries of Wales
Fig.20

37 **The Victim**
Tailpiece to *In Parenthesis*
1937
Pencil, ink and watercolour
38.1 x 28
National Museums & Galleries of Wales

38 **Guenever**
1940
Pencil, ink and watercolour
62.2 x 49.5
Trustees of the Tate Gallery
Fig.23

39 **The Four Queens**
1941
Pencil, ink and watercolour
62.2 x 49.5
Trustees of the Tate Gallery
Fig.24

40 **Study for Aphrodite in Aulis**
1938–40
Pencil
32.7 x 21
Trustees of the Tate Gallery

41 **Aphrodite in Aulis**
1941
Pencil, ink and watercolour
62.9 x 49.5
Trustees of the Tate Gallery
Fig.25

42 **Epiphany 1941: Britannia and Germania Embracing**
1941
Pencil, ink and watercolour
29.9 x 23.5
Trustees of the Imperial War Museum
Fig.27

43 **The Lord of Venedotia**
1948
Pencil, chalk and watercolour
56 x 44.5
British Council

44 **Girl in a Hat**
1950
Pastel
57.8 x 40.2
Casgliad Cyngor Celfyddydau Cymru/
Arts Council of Wales Collection

45 **Sunday Mass: In Homage to G.M. Hopkins, S.J.**
1948
Watercolour, chalk and body colour
55.9 x 38.1
Private Collection
Fig.26

46 **Dwynwen Deg in Livia's Frock**
1948
Chalk, crayon and pastel
65 x 52.3
National Museums & Galleries of Wales
(Only exhibited in Cardiff)

47 **String Song, Tongue Song (Cerdd Dant, Cerdd Dafod)**
1961
Watercolour, gouache and pencil
48.3 x 37.1
Hove Museum and Art Gallery

48 **Trees at Harrow, Winter**
*c.*1950
Watercolour, pastel and pencil
76 x 55.8
Austin/Desmond Fine Art

49 **Vexilla Regis**
1947–8
Pencil and watercolour
75 x 55
Kettle's Yard, Cambridge
Colour Plate 6

50 **Major Hall's Bothy**
1949
Pencil, crayon and watercolour
78.9 x 57.4
National Museums & Galleries of Wales

Inscriptions

A feeling for lettering as a creative act was probably fostered for Jones during his time with Eric Gill. He certainly developed a sense of image to text and text to image in the various book projects he was involved with in the 1920s. In the 1930s David Jones made informal inscriptions as presents and Christmas gifts. In 1948 he made a series of experimental inscriptions, whilst his historical interests were encouraged by such artistic admirers as Nicolete Gray, who presented Jones with her academic work on palaeography completed in the same year. Jones, however, moved towards choosing and combining his own texts often from varying sources and languages. As his pictures became ever more compressed and textually complex, so his inscriptions sought the clarity of showing text as image – David Jones maintained 'when they come off (and that's not all that often) they are much more satisfactory to me than most of my work'.

51 **Dum Medium Silentium**
1952
Opaque watercolour on an underpainting of Chinese white
49.6 x 62.9
Board of Trustees of the Victoria and Albert Museum, London

52 **Cara Wallia Derelicta**
1959
Opaque watercolour on an underpainting of Chinese white
58.4 x 38.7
National Library of Wales, Aberystwyth
Colour Plate 8

53 **Mabinogi Iesvcrist**
*c.*1950s
Watercolour and white chalk
66 x 54.6
National Museums & Galleries of Wales

54 **Cum Lucia**
*c.*1950s
Watercolour
39.3 x 30.5
Casgliad Cyngor Celfyddydau Cymru/
Arts Council of Wales Collection

55 **Mulier Cantat**
1960
Opaque watercolour on an underpainting of Chinese white
57.8 x 38.1
National Museums & Galleries of Wales

Of Metamorphosis and Mutability

David Jones believed in slipping from one world to another, from subject to symbol, from sign to understanding, from notation to connotation. A number of pictures in the early 1930s and again in the late 1940s and early 1950s depict the most insubstantial and translucent elements – flowers in water in glass chalices in light – to create a rich play of meanings and experiences combining the quest for the Grail and the idea of transubstantiation embodied in the Mass. These are pictures poised between palpable and impalpable worlds.

56 **Briar Cup**
1932
Pencil and watercolour
76.5 x 55.2
Private Collection
Colour Plate 4

57 **Hierarchy**
1932
Watercolour
76.5 x 55.2
Private Collection

58 **The Tangled Cup**
1949
Pencil, rubbed charcoal, watercolour, gouache and coloured chalk
77.6 x 56.9
Birmingham Museums and Art Gallery

59 **Mehefin**
c.1950
Pencil, crayon, watercolour and body colour
57.8 x 77.5
National Museums & Galleries of Wales
Colour Plate 5

60 **Chalice with Flowers and Seal**
1950
Pencil, crayon, watercolour and gouache
76.5 x 65.2
Casgliad Cyngor Celfyddydau Cymru/
Arts Council of Wales Collection

61 **Chalice with Flowers**
1949
Pencil, watercolour, pastel and crayon
74.5 x 65
Private Collection

Last Offerings

'I'm struggling with my Tristan picture. I've transferred it now onto another piece of paper – which is a ghastly operation – but I could not do what I wanted with it on the original paper, and I did not want to lose the feeling of it by making the endless alterations and adjustments which I wish to make … The first one now becomes rather like the natural scene and the one I'm working on the actual "art-work" – the offering is the same, but under another mode, as it were … I don't know whether I shall pull it off – it's the hardest thing I have tried to do …'

David Jones in a letter of 12 March 1960 From *Dai Greatcoat: A Self Portrait of David Jones in His Letters*, René Hague (ed.), p.177

Trystan ac Essyllt and *Y Cyfarchiad I Fair* were Jones's last large scale compositions – both images attempting to hold together worlds of experience, myth, history and symbolic presences.

62 **Trystan ac Essyllt**
c.1959–60
Pencil, watercolour and gouache
75.6 x 55.9
National Museums & Galleries of Wales

63 **Trystan ac Essyllt**
c.1962
Pencil, watercolour and body colour
77.5 x 57.1
National Museums & Galleries of Wales
Colour Plate 7

64 **Y Cyfarchiad I Fair (The Greeting to Mary/Annunciation in a Welsh Hill Setting)**
1963
Pencil, crayon and watercolour
77.5 x 57.8
National Museums & Galleries of Wales
Fig.29

List of Lenders

Numbers given refer to the Catalogue listing

Austin/Desmond Fine Art 25, 26, 48
Birmingham Museums and Art Gallery 58
The British Council 43
Casgliad Cyngor Celfyddydau Cymru/Arts Council of Wales
 Collection 24, 27, 32, 44, 54, 60
Trustees of the Cecil Higgins Art Gallery, Bedford 35
City Museum and Art Gallery, Stoke on Trent 11
Cleverdon Collection 8 (and cased material)
Glynn Vivian Art Gallery, Swansea 12
Hove Museum and Art Gallery 47
Trustees of the Imperial War Museum, London 42
Trustees of the David Jones Estate 5
Kettle's Yard, Cambridge 49
Kirklees Metropolitan Council, Huddersfield Art Gallery 15
Manchester City Art Galleries 30
National Library of Wales, Aberystwyth 2, 18, 52
National Museums & Galleries of Wales, Cardiff 3, 4, 9, 10, 13, 14,
 19, 20, 36, 37, 46, 50, 53, 55, 59, 62, 63, 64
Private Collections 1, 6, 16, 21, 22, 23, 28, 33, 34, 45, 56, 57, 61
Trustees of the Tate Gallery, London 7, 31, 38, 39, 40, 41 (and
 cased material from the Tate Archive)
Towner Art Gallery, Eastbourne 29
Trustees of the Victoria and Albert Museum, London 51
The Whitworth Art Gallery, University of Manchester 17

Select Bibliography

Major books and catalogues on David Jones's visual art.

Paul Hills, *David Jones*, Tate Gallery, London 1981
Nicolete Gray, *The Painted Inscriptions of David Jones*, Gordon
 Fraser, London 1981
Douglas Cleverdon, *The Engravings of David Jones*, Clover Hill
 Editions, London 1981
Nicolete Gray, *The Paintings of David Jones*, John Taylor/Lund
 Humphries/Tate Gallery, London 1989
Caroline Collier et.al., *David Jones: Paintings, Drawings,
 Inscriptions, Prints*, The South Bank Centre, London 1989
Jonathan Miles and Derek Shiel, *David Jones: The Maker Unmade*,
 Seren Books, Bridgend 1995